GAINING MUSIC LITERACY

A FIFTEEN-WEEK PROGRAM FOR MUSIC NEOPHYTES

STEPHEN JABLONSKY

The City College of New York

Kendall Hunt
publishing company

Cover image © Shutterstock, Inc.

www.kendallhunt.com
Send all inquiries to:
4050 Westmark Drive
Dubuque, IA 52004-1840

Copyright © 2014 by Stephen Jablonsky

ISBN 978-1-4652-4688-2

Printed in the United States of America
10 9 8 7 6 5 4 3 2 1

TABLE OF CONTENTS

SCHEDULE OF ASSIGNMENTS

	READING	RHYTHMS	SINGING	KEYBOARD
Week 1	1. Fascinating Rhythms 2. The World of Pitch	Etude 1 and 2	Rhythm Etudes	Copy Kat 1,2, and 3
Week 2		Etude 3 and 4	Rhythm Etudes	Copy Kat 4, 5, and 6
Week 3	**Pitch Test**	Etude 5 and 6	Song 1	Dos Manos 1 and 2
Week 4	3. The Basics: Scales and Keys	Etude 7 and 8 Two Hands 1	Song 2	Basement Blues Dos Manos 3 and 4 Scalar Adventures
Week 5	**Scale Test**	Etude 9 and 10 Two Hands 2	Song 3	Polly Wolly Doodle Major Scales
Week 6	4. Measuring with Intervals	God Save the Queen	Song 4	Blow Ye Winds Sakura
Week 7	**Interval Test**	Yankee Doodle	Song 5 Duet 1	God Save the Queen Key Intervals Going Together
Week 8	5. Harmonizing with Triads	Etude 11 Two Hands 3	Song 6	Minor Scales You Are My Moonshine
Week 9	**Triad Test**	Two Hands 4	Song 7 Duet 2	Primary Triads Major Home Sweet Home
Week 10		Etude 12	Song 8	Cradle Song Yankee Doodle
Week 11	**Triad Test**		Song 9 Duet 3	King Wenceslas Primary Triads Minor
Week 12			Song 10	Simple Gifts
Week 13	**Practice Final 1**		Song 11 Duet 4	Drink to Me Only
Week 14	**Practice Final 2**		Song 12 Trio: Hymn	Merry Widow
Week 15	**Written Final Exam**	**Etudes 9-12 plus Two Hands 1-4**	**Sight Singing plus Song 12**	**Silent Night plus Scales and Progressions**

The study of music is a cumulative activity. Throughout your career you continue to add new music to your repertoire, but at the same time you continue to rehearse the music you already know. At the end of this semester it is expected that you will have all of the musical challenges listed above ready to perform. Good musicians know that there is no easy music; that even the simplest piece needs to be played at speed with great care and attention to detail. It is not enough to play the notes; you need to play the music, and the music must flow smoothly from beginning to end. If you can do all that you are ready to become a music major. Remember, the end of the semester is not the end of your need to work on these challenges. Make them part of your daily regimen and you are on your way to becoming a musician.

Marche Slav, the last piece in your book, is to be practiced during the mid-semester break along with all the other songs in your book so that you can perform them flawlessly for your peers on the first day of the next semester.

INTRODUCTION

Thinking of Majoring in Music But Can't Read a Note?

In the past several years an increasing number of students have enrolled in college with no particular major in mind. When asked by advisors to choose a subject they would like to study many of them opt for music without realizing what that entails. If you are of college age and you still cannot read music or play an instrument proficiently it will be very hard for you to succeed as a music major without a great deal of time and effort invested in the remediation your deficiencies. At this critical moment in your career you have to ask yourself if you want to be a music student or a musician. A music student takes a bunch of courses and hopes for the best. A musician is someone who devotes many hours each day to his or her personal growth and development. They do this every day of the week, every week of the year. There are no vacations or holidays from this regimen. You must constantly be learning new things and overcoming increasingly difficult challenges. Being a musician is a calling, not an avocation. It involves the relentless pursuit of truth and beauty. It is an endeavor where one is never satisfied with one's achievements because the ultimate goal (though unachievable) is perfection.

Musicians make music. At the very least, they do this in two ways: they sing and they play an instrument. The singing they do because there is an impulse within them that drives them to vocalize. They play an instrument because they want to be able to use beautiful sounds to communicate something significant to other human beings. The magic and mystery of music intrigues and entrances them, and they hope some day to be able to perform something special using the techniques they have been taught.

Success in music is dependent on three things: talent, training, and hard work. Talent is something you are born with; it cannot be acquired or learned. Some people are greatly talented; others are less so. Training is crucial because without the guidance of a professional giving you regular lessons, at least every other week, you have almost no chance of success. "He who has himself for a teacher, has a fool for a student." Only a professional can help you correct your mistakes and overcome the challenges your instrument presents. Hard work is what you do as you practice every single day to incorporate the guidance your teacher has given you. It is a well-known fact that a talented student with the proper teachers needs ten years to master an instrument. This mastery means that you are

prepared to practice and perform the great works written for your instrument. It also means that you can perform with proficiency and musicality in ensembles with other equally skillful musicians.

It is hoped that you will eventually become an informed performer. That means you must also study music theory and history. These will help you understand the compositional process, appreciate how music is constructed, give you a sense of style and context, and explain the reasons why the music you perform or hear was composed to sound the way it does. All of these tools will help you in your interpretation and realization of the works you study.

If you are truly a rank beginner, and are not musically literate, you will need to take a course that teaches how to read music and sing what you read. You should acquire some proficiency playing the piano because it is at the keyboard that we come to understand the relationship of rhythm, melody, and harmony. If you get an A in both courses you will build an intellectual and musical foundation that will prepare you for future success, If you get a B in these two courses you have a fair chance of eventually graduating with a music degree if you continue to plug away at the challenges. The grade of C indicates that you may need to take some time off before moving to the next level in order to gain the mastery that currently eludes you. It won't be easy, but it will be an exciting adventure. It is only fair to warn you that music may well be even harder than mathematics. In math you have to get the right answer or fail. In music you not only have to play the right notes on the right beats, but it must be done with great skill, care, and sensitivity. It is not enough to be right; it must also be beautiful! This will be a lifelong journey. Are you ready to begin?

Goals for the Elementary Musicianship Class

What is contained in this book is essentially a pre-college course. The information herein is traditionally, and more easily, learned in childhood. So, you have to realize that you are at least 10 years behind schedule and need to get to work on your deficiencies TODAY. You need to confidently absorb this material in order to move to the next course in your music major sequence. You have fifteen weeks to learn a great deal of material that will prepare you for college-level music classes. At the end of the semester you should know and do the following with a sense of mastery.

1. Write and play all major and minor scales and key signatures.

2. Know the functional names of the scale steps.

3. Write and perform all of the intervals contained within those scales (one octave).

4. Write and perform all of the triads built on those scales.

5. Write and perform all rhythmic values from whole notes to dotted eighth/sixteenth note combinations. Rests, too.

6. Sight-sing simple melodies in major and thereby demonstrate that you are musically literate.

7. Do melodic dictation at a rudimentary level.

WARNING: The materials in this course need to be <u>memorized</u> so that you have this information at your finger tips just the way you know other critical data like your address and phone number.

ADVICE: You would do well to use one of the many fine music literacy websites such as <u>Teoria.com</u> in conjunction with this textbook so you can reinforce what you learn here and also have the opportunity to hear the scales, intervals, and triads you need to recognize by sight and sound.

Goals for the Beginning Keyboard Class

This course should be taken along with Elementary Musicianship because they are mutually reinforcing. At the end of this course students should be able to know and do the following.

1. Accurately read treble and bass clefs together.

2. Know and perform rhythmic values up to dotted eighth/sixteenth combinations in 6/8 meter.

3. Know and perform 2/4, 3/4, 4/4, and 6/8 meters.

4. Play all major and minor scales up to 4 flats and 4 sharps: one octave, one hand.

5. Play chord progressions and pieces that use the three primary triads in root position and inversion in all major keys up to three flats or three sharps.

6. Play five-finger pieces with melody in one hand and primary triads in the other in different keys and meters.

7. Transpose a simple five-finger melody to another key.

8. Play pieces that begin to move out of the five-finger position employing simple shifts of hand position.

CHAPTER 1

FASCINATING RHYTHMS

Fascinating Rhythm,
You've got me on the go!
Fascinating Rhythm,
I'm all a-quiver.

The lyrics to the George and Ira Gershwin hit song from 1924 say it all. The excitement of studying and performing music begins with rhythm.

Rhythm

Of the four basic parameters of music—rhythm, melody, harmony, and timbre—the first is the most basic and the place where we begin our study of music. Everything we do in music starts with rhythm. Melody and harmony may be added later but are not necessary for a satisfying musical experience. Rhythm refers to the duration of sounds and the duration of the spaces (rests), or lack of spaces, between them. Rhythms are considered regular when they contain recognizable patterns and there seems to be a reasonable system of expectation in the musical narrative. On the other hand, rhythms may be irregular when we cannot anticipate with assurance what might come next because we do not sense an integral logic born of pattern. Rhythms can be very simple, consisting of a small number of durations or it may be highly complex. Volumes could be written about this intriguing subject but the discussion here is kept brief in the interest of practicality and because it is more fun to perform rhythms than to read about them.

It is important to understand that we read rhythms the same way we read language. As you read this introduction your eye is taking in sizable batches of data at one time, perhaps several words at once. You are not reading each letter separately and then forming them into words. So it is with rhythm. Your job is to familiarize yourself with the common patterns employed in various meters in order to be able to recognize them as the musical equivalents of words and phrases. The skilled musician often takes in half measures, whole measures, or even pairs of measures at a glance depending on the complexity of the patterns and th tempo.

Meter

Most music has at the heart of its rhythmic structure an underlying pulse known as the beat—the steady, measured throbbing on which all the rhythmic values are based. Most of the music of the past four hundred years is metrical; that is, the beats are grouped into recognizable patterns the most common of which are two beats per group (duple meter) or three beats per group (triple meter). These groupings are known as measures and are separated by bar lines when notated. The first beat of each group gets an accent and is performed with some increased level of energy. This first beat is known as the downbeat because conductors indicate the beginning of each measure with a downward motion of the hand or baton. The last beat of each measure is known as the upbeat and the conductor's hand or baton should move accordingly. In essence, all beats other than the downbeat are considered upbeats—duple meter is counted "DOWN-up" while triple meter is counted "DOWN-up-up." When triple meter moves very quickly it is often counted in one.

Time Signatures

We use a fraction, known as a time signature, at the beginning of every piece to notate the meter. The numerator (upper number) tells us the number of beats per measure while the denominator (lower number) tells us which of our rhythmic symbols will represent the beat. The symbols (notes) in common use are as follows:

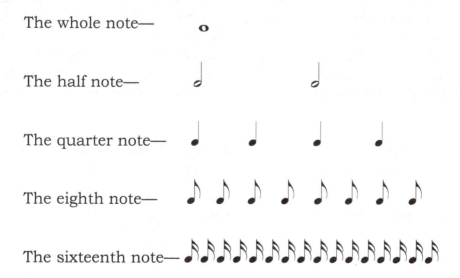

The whole note—

The half note—

The quarter note—

The eighth note—

The sixteenth note—

As you can tell from their names, they are part of a relative value system that is based on a division by two. There are also double whole notes as well as 32nd notes, 64th notes, and the very rare 128th notes.

The time signature for marching music is 2/4 in which every measure has rhythmic symbols that add up to the equivalent of two quarter notes. When you are dancing the waltz the music you hear is written in 3/4 time. A great deal of music is written in 4/4 or what is known as common time, indicated by an upper case C instead of the fraction. In 2/4 time the first beat is accented and the second is not (**ONE**, two, **ONE**, two or **LEFT**-right, **LEFT**-right). In 3/4 time the first beat is accented and the two that follow are not (**ONE**-two-three, **ONE**-two-three). In 4/4 time the primary accent occurs on the downbeat and there is a subsidiary accent on the third beat that begins the second half of the grouping (**ONE**-two-**three**-four, **ONE**-two-**three**-four).

There are many pieces that have time signatures that use the eighth note to represent the beat. Perhaps the most common of these is 6/8. This is a form of duple meter in which each half of the measure is divided into three beats. We apply the term "compound" to 6/8, 9/8, or 12/8 meters that have triple divisions of the beat. In 6/8 time the main accent is on beat one and the subsidiary accent is on beat four (**ONE**-two-three-**four**-five-six). You may occasionally see a composition written in 3/8 time and the use of the less common eighth value usually indicates a desire on the composer's part for a performance that feels lighter than 3/4 time.

You may occasionally run across music that uses the half note as its common note value. The most common of these is known as "cut time" (2/2 or ¢) and is generally used for music that would ordinarily be written in 4/4 but is moving too fast to warrant the counting of the weak beats (two and four). The music in cut time looks exactly the same as 4/4 but the weak beats are subordinated even further. The tempo often affects the way in which music will be perceived or performed. A piece in a moderate 3/4 time will be counted in groups of three beats but at a higher rate of speed it may be counted in one.

We use a variety of symbols called "rests" to indicate the absence of sound. The symbols in common use are as follows:

 The whole rest— ▬ below the middle line

 The half rest— ▬ above the middle line

 The quarter rest— ╏

The eighth rest— ,

The sixteenth rest— ,

Rests are more difficult to perform than notes because we must wait the appropriate amount of time without making a sound. For most of us that is often very hard to do. A rest does not mean "do nothing," it means "count." The longer the rest, the more patient you must be. It is often helpful to say "rest" when you are having difficulty with this form of negative sound space.

Tempo

Tempo refers to the speed of the beat. At the beginning of each composition there is either a word or metronome marking that indicates how fast the piece should be performed. Your first attempt to perform any activity in this book should be done at half speed. If you practice too quickly your performance may be filled with mistakes that are very hard to un-learn later. Very few of the etudes in this book have tempo designations because it is expected that you will begin to practice each one of them at a pace that is comfortable. When you have mastered the material at that speed you may gradually speed up the tempo until it reaches the appropriate speed. Accuracy comes first; speed comes later.

Metronome markings indicate the number of beats per minute. For example, "march time" (2/4) is usually performed at "quarter note equals 120" which means that there are 120 beats per minute or two beats per second. Every serious musician owns a metronome. When you practice with a metronome it keeps you honest and tests your ability to stay in tempo.

You may also find that the tempo is indicated by a word, often in a foreign language such as Italian, French, or German. Here are some of the common Italian terms in order of speed:

Grave—very slow
Largo—slow and broad
Lento—moderately slow
Adagio—slow and easy
Andante—at a comfortable walking pace
Moderato—moderate (not too fast and not too slow)
Allegretto—moderately fast
Allegro—fast
Vivace—fast and lively
Presto—very fast
Prestissimo—as fast as possible

If you wish the performer to slow down gradually use the term *ritardando*. The term *accelerando* is used to indicate a gradual speeding up. From time to time, you may wish to employ these in the performance of a particular rhythmic etude.

Ties and dots

We join two notes together by the use of a tie, a curved line connecting two note heads. For example, in 4/4 time a half note may be extended by tying it to another note. To create a note that lasts three beats you may either tie a half note to a quarter or merely place a dot after the note head. This dot represents the quarter to which it is tied and is a form of abbreviation. The dot always represents half the value of the note that is dotted. Therefore, a dotted quarter note is equal in length to a quarter note tied to an eighth. And, a double dotted quarter is equal to a quarter tied to an eighth tied to a sixteenth.

Rests may also be dotted.

Dynamics

Dynamics refer to the volume of sound (loudness). The following abbreviations from the Italian are in common usage. They are listed in order of loudness.

> *ppp—pianississimo* (as soft as possible)
> *pp—pianissimo* (very soft)
> *p—piano* (soft)
> *mp—mezzo piano* (moderately soft)
> *mf—mezzo forte* (moderately loud)
> *f—forte* (loud)
> *ff—fortissimo* (very loud)
> *fff—fortississimo* (as loud as possible)

To indicate an increase in volume we use the term *crescendo*. To indicate a decrease in volume the term *decrescendo* is used.

No dynamic markings have been used in this chapter. I suggest that when you are preparing a performance of any of these activities that you make your own decisions about volume. Experiment until you find a pleasing balance of soft and loud. Obviously, the emotional effects created by dynamic manipulation will greatly affect your listeners. A phrase performed

pianissimo will send an entirely different message when the dynamic level is increased to *fortissimo*.

Counting Rhythms

Sometimes it helps to scat sing those rhythms that are problematic. For example, in music that uses time signatures with the quarter note representing the beat you can use the numbers of the beats, "and" for 8th notes on the second half of the beats, "e" (say ee) for the second 16th, and "a" (say ah) for the fourth 16th. Here is an example in 4/4 meter:

1 2 3 4 | 1 & 2 & 3 & 4 & | 1 e & a 2 e & a 3 e & a 4 e & a |

When you encounter music that moves too rapidly for you to articulate comfortably it is time for double- and triple-tonguing. For rhythmic figures that are divisible by 2, use either of the following double-tonguing techniques. For light double-tonguing practice saying "tah–kah" or "tah–kah–tah–kah." For a heavier sound use "duh–guh–duh–guh." When the rhythmic figure is divisible by 3, use either "tah–tah–kah" or "duh–duh–guh." Practice these tonguing techniques, which are commonly employed by woodwind and brass players, slowly at first and then increase the speed until you are so good that you can amaze your friends and family.

Performing the Etudes

Here are some ways you might perform the following etudes:

1. Tap the beats with one hand and tap the rhythm with the other. Now switch hands.

2. Tap the downbeats with one hand and the rhythm with the other. Now switch hands.

3. Tap the beats with one hand and sing the rhythm.

4. Tap the beats with your foot and sing the rhythm.

5. Say the beats and play the rhythm on your keyboard.

READING RHYTHMS

It took thousands of years to develop what I am about to share with you. Our system of rhythmic notation uses symbols to represent relative lengths of tones. At the heart of the system is the concept of doubling or halving the values. For example, the first note you see is called a whole note. The two notes that follow it are called half notes because they last half as long as the whole. The next four notes are called quarter notes because they last one quarter the length of the whole note, and half the length of the half note. Following those you see eighth notes, and by now you know why they have that name.

The music you are most familar with is based on what we call meter. When we listen to music we very often sense an underlying pulse to the rhythmic activity of the piece. These pulses are called beats and when we clap along with the music we usually clap the beats. When beats are grouped in identifiable patterns we call that meter. Traditionally, the first beat of every group gets an accent by being slightly louder than the other beats. This helps us find our place in the rhythmic structure. If the meter has two beats we say it is duple. If it has three beats we call it triple meter. Four beats are also duple because it is divisible by two.

The music below has something we call a time signature--the fraction at the beginning. The numerator tells us how many beats are in every group and the denominator tells us what kind of note will represent the beats. This one tells us there are four beats in each group represented by quarter notes. The groups are separated by a bar line into what we call measures. All the note combinations below add up to four quarters in every measure. See if I am right.

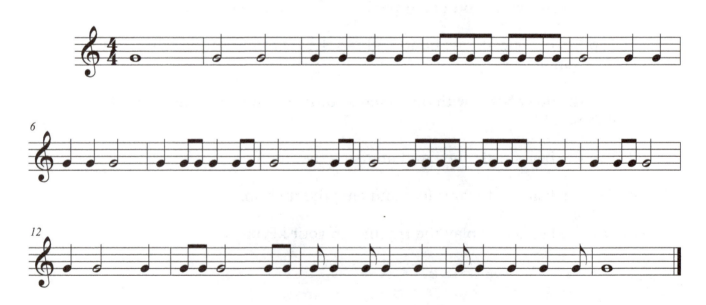

RHYTHM ETUDE 1

Whole Notes, Halves, and Quarters

RHYTHM ETUDE 2

Introducing Triple Meter

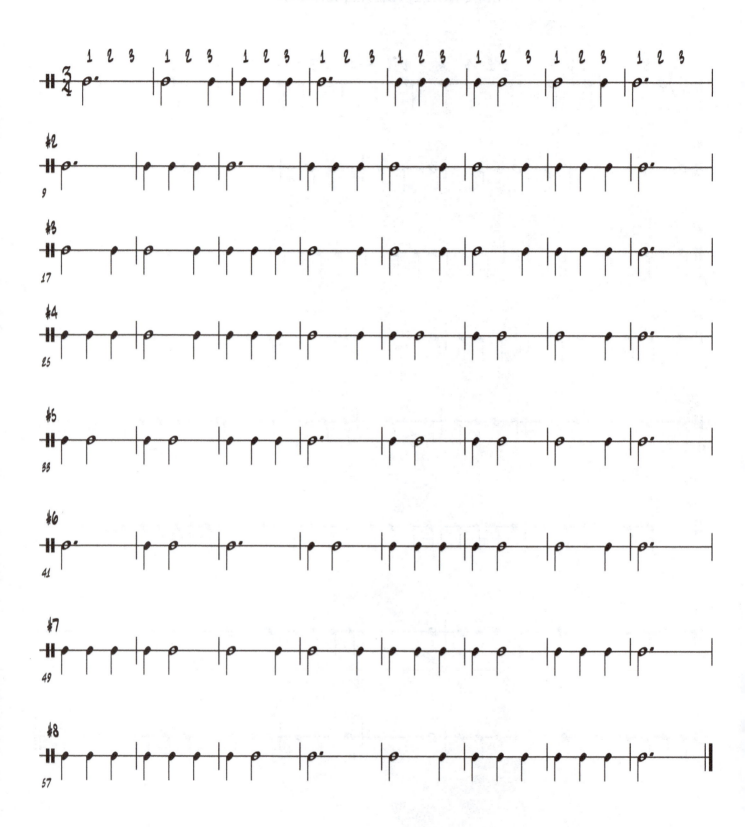

RHYTHM ETUDE 3

INTRODUCING RESTS

RHYTHM ETUDE 4

TRIPLE METER WITH RESTS

RHYTHM ETUDE 5

INTRODUCING TIES

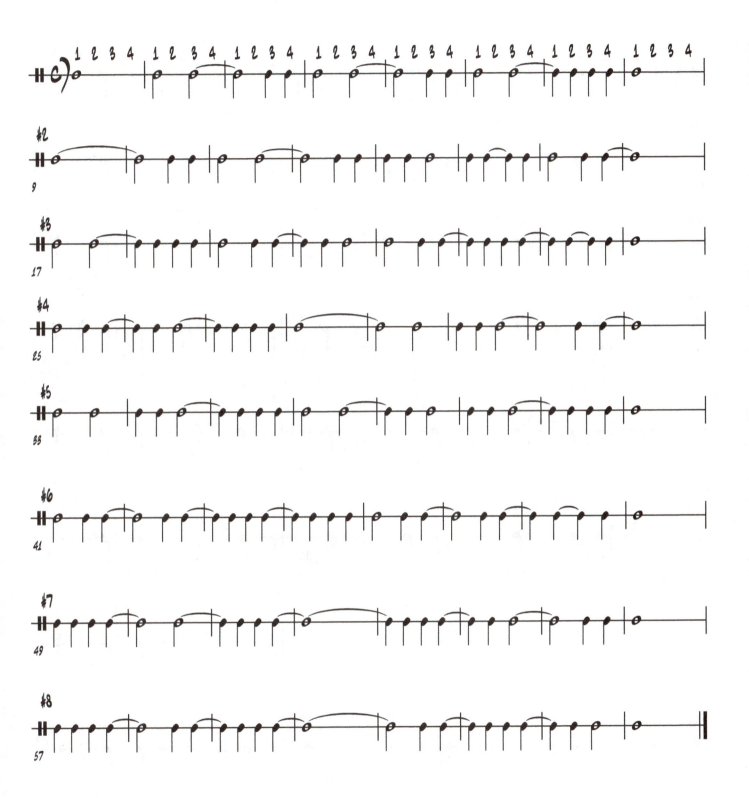

RHYTHM ETUDE 6

TRIPLE METER WITH TIES

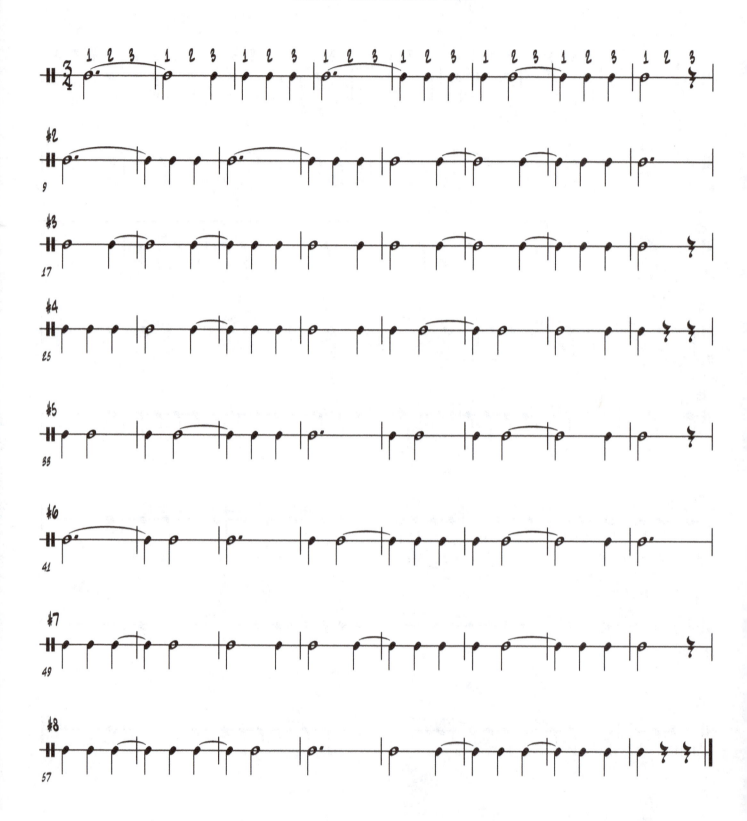

RHYTHM ETUDE 7
READING TIES AND RESTS

RHYTHM ETUDE 8
INTRODUCING EIGHTH-NOTES

RHYTHM ETUDE 9

EIGHTH-NOTES IN TRIPLE METER

RHYTHM ETUDE 10

INTRODUCING DOTTED QUARTERS AND EIGHTHS

RHYTHM ETUDE 11

INTRODUCING COMPOUND METER

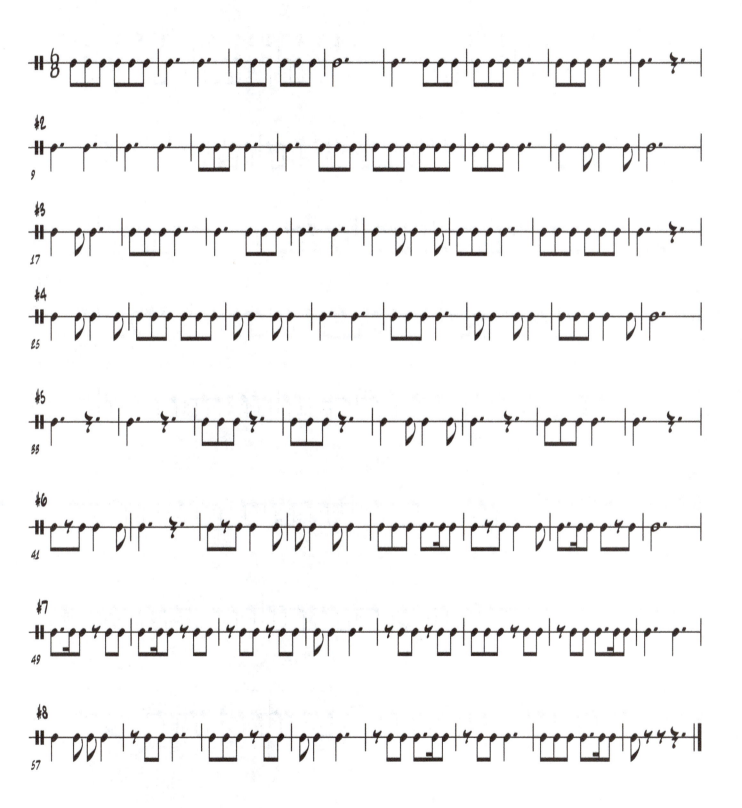

RHYTHM ETUDE 12

A bit of everything

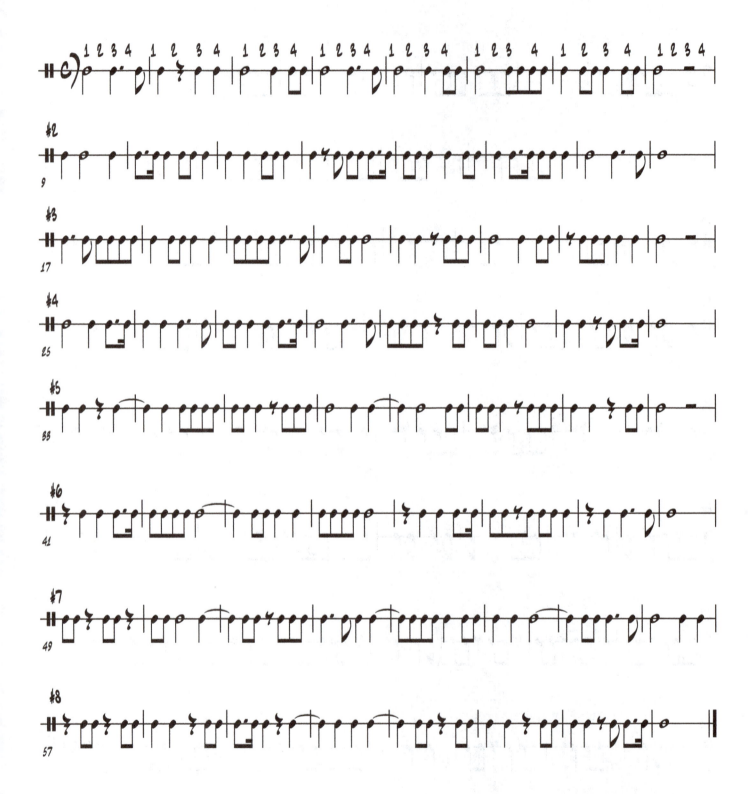

TWO HANDS 1
Duple Meter

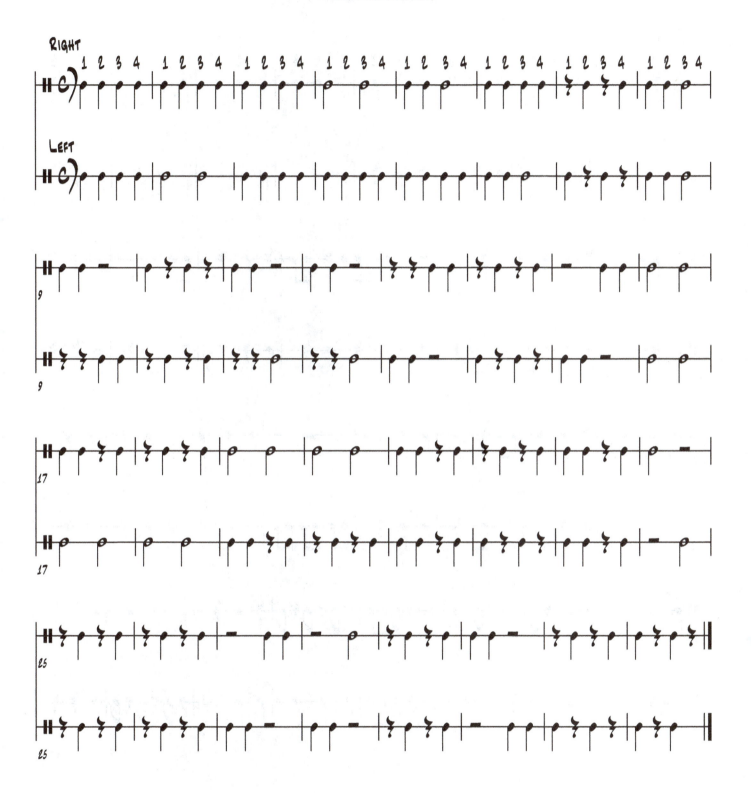

TWO HANDS 2

TRIPLE METER

TWO HANDS 3

Duple Meter with ties

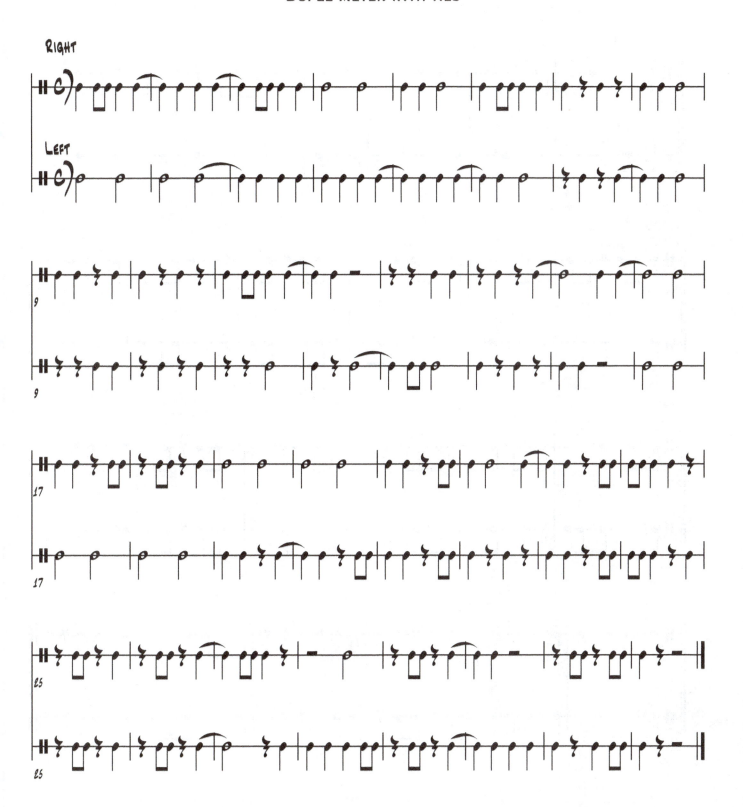

TWO HANDS 4

COMPOUND METER

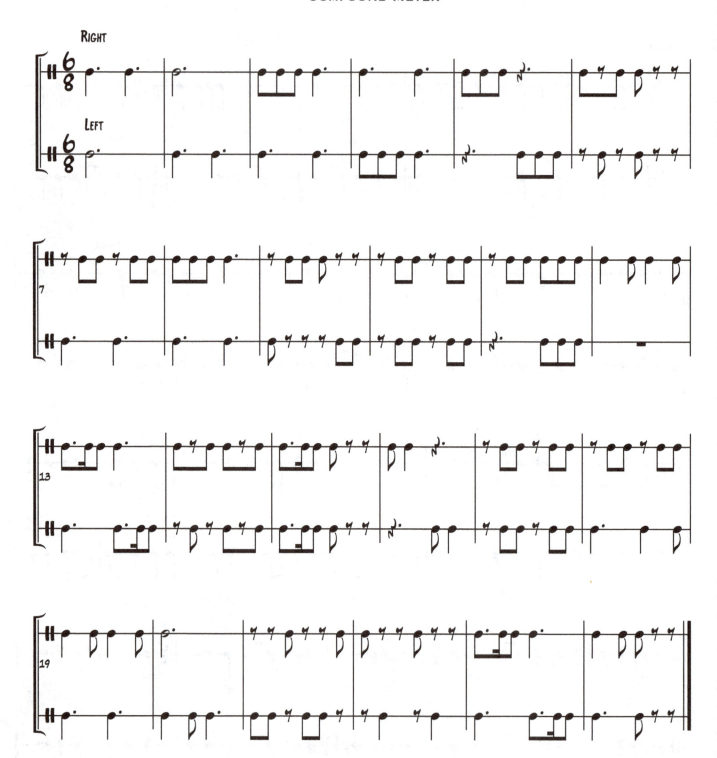

GOD SAVE THE QUEEN

BRITISH NATIONAL ANTHEM*

Do this as a two hand rhythm etude then go to the keyboard.

***SOME COLONIALS KNOW THIS AS "AMERICA"**

YANKEE DOODLE

INTRODUCING DOTTED-EIGHTHS AND SIXTEENTHS

Do this as a two-hand rhythm etude and then go to the keyboard.

CHAPTER 2

THE WORLD OF PITCH

OK. You are finally learning to read music. Why you waited this long nobody knows. Maybe you thought it would be hard to do. Well, you are about to discover that it is not. There are two elemental aspects to music notation--pitch and rhythm. Pitch refers to the tones we make with our voice or an instrument. When the sound vibrates at a steady rate it produces what we call tones. We write these tones on what we call a staff--five lines and the four spaces between them. When sounds seem to go up, they go up the page and vice versa. The music you see below begins with that fancy squiggle we call a treble clef. It is used for all the music on the right side of the keyboard. It is also called a G clef because it tells us where to find the note G--on the second line from the bottom. Lucky for you the musical alphabet only goes from A to G.

For demonstration purposes I have written the names of the notes for you in the first half of this piece. Your job is to write the names in the second half. You will notice that notes can go above or below the staff. If we need to, we can add what are called leger lines for notes like the B in measure 7.

Play these notes on your keyboard. It should not be too hard as they are almost all white notes. The black notes between them are called flats and sharps. If you go up from F to G (see m.11) the black note between them is called F sharp (♯). If you go down from G to F (see m. 15) the black note between them is called G flat (♭).

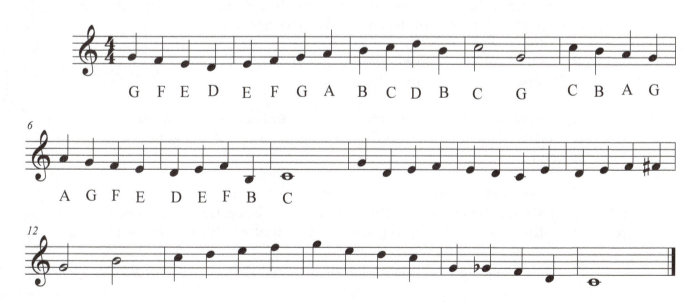

A GUIDE TO MUSIC NOTATION

If you have gotten this far and have decided to move on with your theory studies it is a good idea to study the following material so that your music manuscript will look professional. More importantly, your notation should be easy to read and exact in its directions to performers who need all the help they can get considering how many other things they have to worry about when trying to make music.

The system of notation we use today is the product of a thousand years of experimentation. As music got more and more complicated composers sought more accurate means of representing their intentions. The result we see in modern scores is very efficient but extremely complicated due to the myriad conventions that have accumulated over time. Our system of writing music is known as proportional notation. This means that vertical and horizontal elements are the correct distance apart in representing both pitch and rhythm. For example, a leger line should be the same distance from the upper or lower line of a staff as the lines on the staff are from each other. It also means that half notes should be twice as far apart as quarter notes. Below are a few helpful hints for making your scores look more presentable and easier to read.

1. An accidental affects all of the same pitches for the rest of the measure, but not the same pitch in other octaves. A B flat in the right hand will not affect a B in the left hand.

2. Accidentals are placed on the same line or space as the note head and are in correct proportion to the size of the note.

3. In writing single lines, stems go up if the note head is on or below the middle line of the staff and vice versa.

4. A courtesy accidental, placed in parentheses, may be used to remind the reader of a return to the key signature in the measure following an accidental.

5. When using two or more accidentals in a chord, the upper accidental should be closest to the note heads. Keep them as compact as possible without overlapping. If possible, try to align the highest and lowest.

6. Note heads should be as big as the space between two lines.

7. Use a straight edge to draw bar lines.

8. Align everything by beats. Write chord names above the beat on which they begin and chord numbers below the correct beat.

9. Use beams to join eighth notes and sixteenth notes so that the metrical groupings are obvious to the reader. In other words, do not beam from one beat to the next. Avoid using ties within a beamed grouping. Beams should follow the average direction of the grouping (flat, up, or down).

10. Begin and end each brace with a bar line. End a section with two bar lines. End the piece with a bar line followed by a thicker bar line.

11. When writing piano music, begin each pair of staves with a brace or French curve, a bar line connecting both staves, the clefs, the key signatures, and the time signatures.

12. Do all your work in #2 pencil. Buy a good eraser (you'll need it). Later, when you are really serious about producing good-looking manuscript scores, you would do well to purchase a guide to notation to answer the myriad questions that will undoubtedly arise. When you get really serious about being a musician you should buy yourself a good music notation application such as Finale or Sibelius.

THE CHROMATIC SCALE

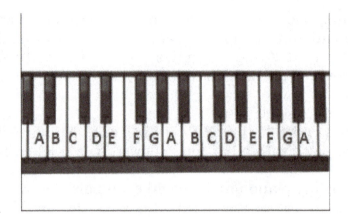

Lucky you! The entire world of music theory involves only 12 notes. If you look at the keyboard above you will notice that the letters of the musical alphabet run from A to G accounting for all the white notes. Therefore, we use seven letters and then repeat at the octave (the eighth note). In every octave there are five black notes. The names of these notes derive from the direction from which they are approached. If you go up from A to B, the intervening black note will usually be called A sharp (♯). If you go in the opposite direction the same black note is called B flat (♭). If you play all 12 notes between A and A we call that the chromatic scale. This is also true starting on any note.

Just to make sure you understand, label all the keys below. Notice that the black notes are arranged in groups of two and three. That should get you started. When you play a chromatic scale you are rising or falling by what we call semitones or half steps. Try playing it on your keyboard using more than one finger. For good fingering, remember "thumb under" and "middle finger over" when needed.

Below you will see the chromatic scale starting on A. In the traditional fashion we use sharps on the way up and flats on the way down. You can build a chromatic scale beginning on any note. Label the notes in both directions. Play it every day on your keyboard. You only need three fingers!

The chromatic scale

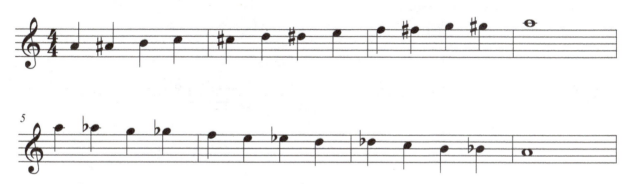

Enharmonics:

We say that two notes are enharmonic if they are spelled differently but sound the same. In the examples below the notes in each measure sound the same and are played on the same key of the keyboard. Enharmonics are determined by the key of the piece or thedirection in which the line is moving. You will notice that the world of pitch also includes double sharps (×) and double flats.

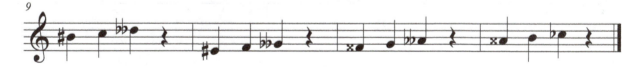

NAME THE NOTES 1

The notes on the five lines in the treble clef are E - G - B - D - F reading from the bottom up. The spaces between them are F - A - C - E.

Practice this page many times until you can name all the notes in one minute. Each correct answer is worth 3 points.

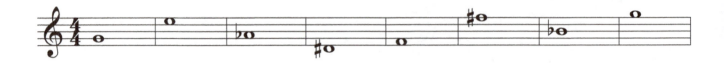

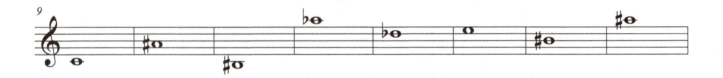

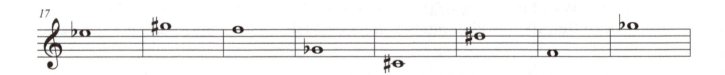

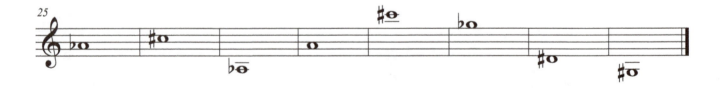

NAME THE NOTES 2

Practice this page many times until you can name all the notes in one minute.
Each correct answer is worth 3 points.

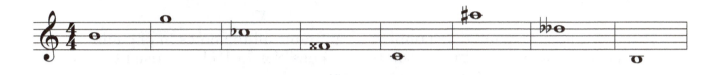

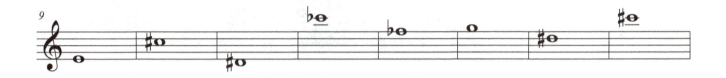

NAME THE NOTES
IN THE BASS CLEF 1

The bass clef covers all the notes on the left side of the keyboard. The bass clef is also called the F clef because it tells us where F is located--on the fourth line from the bottom, between the two dots. The notes on the lines in the bass clef are G - B - D - F - A reading from the bottom up. The spaces between them are A - C - E - G.

Practice this page many times until you can name all the notes in one minute. Each correct answer is worth 3 points. The bass clef, or F clef, is used to notate the pitches below middle C on the keyboard.

NAME THE NOTES
IN THE BASS CLEF 2

Practice this page many times until you can name all the notes in one minute.
Each correct answer is worth 3 points.

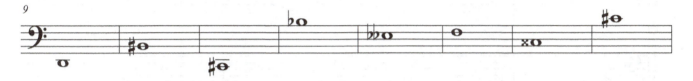

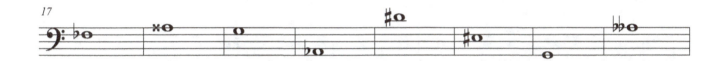

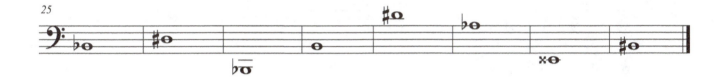

BASEMENT BLUES

Stephen Jablonsky

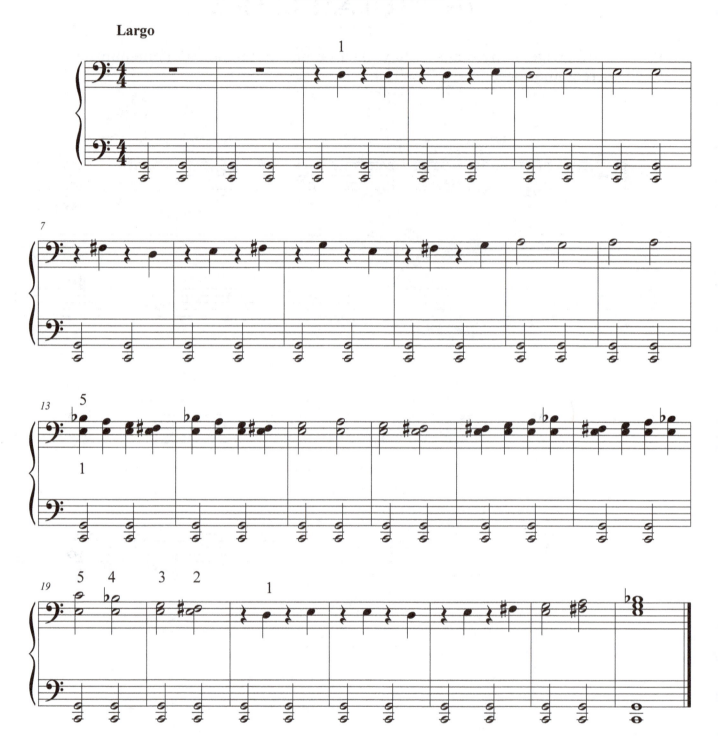

CHAPTER 3

THE BASICS:
SCALES AND KEYS

Back to basics

The materials of music are sound and silence. **Silence** refers to the spaces that help to articulate the sounds and make the musical message clearer. The training of a skilled composer must include information on how to use silences as well as **pitches**, which are tones of specific frequency (vibrations per second), and **noises**, which are sounds of indeterminate pitch. Music itself is a highly unnatural phenomenon—a man-made artifice. Of its three components, silence and noise are universal natural elements while pitch manipulation may only be encountered in nature's singers such as birds, whales, and wolves. But, what of chords and chord progressions? Never. To harmonize is human.

Young, healthy human beings can hear sounds in a range from 20Hz (20 vibrations, or wave cycles, per second) to 20kHz (twenty thousand vibrations per second). As we get older our range may diminish, especially if we, as adolescents, have abused our aural equipment in pursuit of sensory overload. "Hz" is the abbreviation for the last name of the 19th-century German physicist Heinrich Hertz who is honored by this appellation. Within this range it has been known since the time of Pythagoras that the doubling or halving of a frequency results in two tones, played consecutively, that will sound the same except that one is "higher" than the other. For example, a tone of 100Hz will sound the same as a tone of 200Hz or one of 50Hz. When the two tones are played together they seem to blend perfectly into one combined tone. We call this doubling an **octave** because, in the scales of the ancient Greeks, the doubled note was eight tones higher than the first. It is for this reason that we give the same letter name to the eighth tone and so use only seven letters of the alphabet in the construction of scales.

> ➤ Warning: Professional musicians are very exacting in all their musical activities, especially the handling of pitches. You should join them by remembering that A, A flat, and A sharp are not the same note. They all share the same letter, but two of them are black notes on the keyboard and one is white.

The tonal space between two pitches an octave apart may be filled with any number of intermediary tones. Our musical system is based upon the division of the octave into twelve equally spaced tones we call the **chromatic scale**. From among these we may construct any number of other scales including the **pentatonic** (5-note) that has served many cultures very well for millennia. For the past four hundred years, the two **diatonic** (seven-tone) scales that have served tonal composers are known as major and minor. More about these a little later.

The major scale

A scale is a series of pitches ordered by stepwise motion that spans an octave. It may go up or down and is the basis for everything we do in tonal music. It is the wise student who practices scales in both directions, slowly at first and then at increasingly faster tempos. Perhaps the most important scale we use in tonal music is known as the major scale. It is derived from the ancient **Ionian mode** (another name for scale). This series of pitches may be played on the keyboard by ascending or descending from C to C using only the white notes. To understand the construction of this and other scales we measure the distance, or interval, between each of the adjacent tones as well as the distance from the first tone to all of the others. The smallest interval is known as a **semitone** or **half step**. The major scale has half steps between steps 3 and 4 and between 7 and 8 (Example 3-1). All the other steps are **whole steps** (the distance of two half steps). In fact, the major scale is constructed of two equal **tetrachords** (a group of four adjacent notes) each of which contains two whole steps followed by a half step. The two tetrachords are separated by a whole step as follows: whole-whole-half/whole/whole-whole-half.

Example 3-1. The Major Scale

♪ For purposes of abbreviation we use a caret to indicate scale step (e.g., scale step five is abbreviated $\hat{5}$).

The intervals from the first step to the other tones of the major scale are:

Î to $\hat{2}$: major second
Î to $\hat{3}$: major third

$\hat{1}$ to $\hat{4}$: perfect fourth
$\hat{1}$ to $\hat{5}$: perfect fifth
$\hat{1}$ to $\hat{6}$: major sixth
$\hat{1}$ to $\hat{7}$: major seventh

All major scales have the same pattern of whole steps and half steps and are, therefore, **transpositions** (movement to another pitch level) of one another. Unfortunately for beginning theory students not all pieces are in C major so you will have to learn all of the other scales as well. There are no hard keys, just the ones you are not familiar with, yet.

Naming the scale steps

Each of the steps of diatonic scales has a special name relating to its position or function:

$\hat{1}$: **Tonic** (the tonal center)
$\hat{2}$: **Supertonic** (above the tonic)
$\hat{3}$: **Mediant** (half way between the tonic and the dominant above)
$\hat{4}$: **Subdominant** (below the dominant or a 5th below the tonic)
$\hat{5}$: **Dominant** (the power chord which leads to the tonic)
$\hat{6}$: **Submediant** (halfway between the tonic and the subdominant below) ·
$\hat{7}$: **Leading Tone** (leads upward to the tonic by semitone)

Please note that the name "leading tone" does not apply to the 7th step in natural minor. This note, which is a whole step below the tonic, is called "flat 7" or **subtonic** and is labeled "♭$\hat{7}$."

The minor scales

It is important to realize that natural minor, harmonic minor, and melodic minor are all aspects of the same condition—minor. When a composer writes a piece in this mode, elements of each of these scales may be used at different times depending on melodic or harmonic necessities. Thus, you will never see a composition labeled *Sonata in B Harmonic Minor*, it is just *Sonata in B Minor*. At this point you should be asking yourself, "Why is there only one form of major but three forms of minor?" Read on.

Natural minor: If we can characterize the major scale as providing sounds that are bright and happy then the minor scale is its opposite and may be heard as the perfect medium for sonorities that are dark and sad. The minor scale derives from the **Aeolian mode** and may be played on the white notes of the keyboard by ascending or descending from A to A. By comparing this scale to the major scale we notice that its 3rd, 6th, and 7th steps are lower by semitone.

Example 3-2a. A Natural Minor

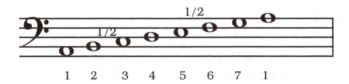

The intervals from the tonic to the other tones of the natural minor scale are:

 Î to 2̂: major second
 Î to 3̂: minor third
 Î to 4̂: perfect fourth
 Î to 5̂: perfect fifth
 Î to 6̂: minor sixth
 Î to 7̂: minor seventh

Harmonic minor: Because the natural minor scale does not contain a leading tone it very often did not suit the harmonic needs of composers of early tonal music who were experimenting with progressions of triads. They needed a strong chord to push to the tonic and the minor chord built on 5̂ did not match the power of the same progression in major. To solve this problem, the leading tone was added to harmonies built on 5̂ and 7̂ that were progressing to the tonic chord thereby creating harmonic minor. This scale has semitones between 2̂ and 3̂, 5̂ and 6̂, and 7̂ and 8̂. Because this scale contains a leading tone, there is an augmented second between 6̂ and 7̂.

Example 3-2b. A Harmonic Minor

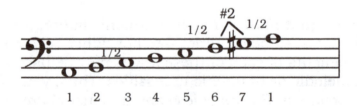

The intervals from the tonic to the other tones of the harmonic minor scale are the same as in natural minor except that Î to 7̂ is a major seventh.

Melodic minor: This scale is an accommodation to the natural tendency of musicians, especially singers, to raise pitches as they approach the tonic in an ascending minor scale. Thus, this scale features raised 6̂ and 7̂ as they pass from 5̂ up to Î. Conversely, musicians often lower these two steps in a descent from Î to 5̂. This, then, is the only scale that varies according to its direction.

Ascending, it consists of the first tetrachord from natural minor followed by the second tetrachord from major. Descending, it is identical to natural minor.

Example 3-2c. A Melodic Minor

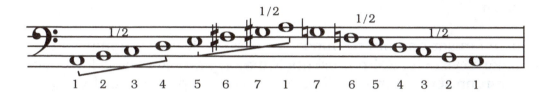

The intervals from the tonic to the other tones of the ascending melodic minor scale are:

î to 2̂: major second
î to 3̂: minor third
î to 4̂: perfect fourth
î to 5̂: perfect fifth
î to 6̂: major sixth
î to 7̂: major seventh

Keys

When we say that a piece of music is in the key of A major we are confirming that it uses the notes of the A major scale. A piece is diatonic if it uses only the notes of the scale on which it is based. A piece is **chromatic** if it introduces some or all of the other five tones of the chromatic scale. Every piece may be viewed as falling somewhere on a scale from strictly diatonic to totally chromatic. What is interesting about the five chromatic notes missing from major is that they form a pentatonic scale. Improvising in the pentatonic scale is fun and easy as long as you stick to the black notes on your keyboard.

Parallel keys are those that share the same tonic. For example, F major (abbreviated FM) is the parallel major of F minor (abbreviated Fm); F minor is the parallel minor of F major. When a composer switches from the parallel major to the parallel minor, or vice versa, to darken or lighten the harmonies, this is referred to as a **change of mode**.
Relative keys are those that share the same key signature but have differing tonics. For example, C major is the relative major of A minor; A minor is the relative minor of C major and they, therefore, appear at the same hour on the Chromatic Circle of 5ths (Example 3-4). The tonic of the relative minor is 6̂ of a major key. The tonic of the relative major is 3̂ of a minor key.

✓ When handwriting the names of keys make sure that your uppercase M is the same size as the letter of the tonic and your lowercase is half the size (FM and Fm). This will make things easier to read.

Key signatures

There are fifteen major and fifteen minor keys. We will use a capital M to designate major keys (e.g., EM represents E major) and lower case for minor keys (e.g., Gm represents G minor). The patterns of steps used in the major and minor scales can be reproduced on any of the tones of the chromatic scale with the use of sharps or flats that are known as **accidentals**. The sharps and flats used in major keys and in natural minor are indicated as the key signature written at the beginning of each staff. This saves the composer the trouble of continually rewriting the accidentals that are part of the scale. The sharps or flats are always written in the same order and on the same line or space of the staff. Sharps go up by fifths (F♯, C♯, G♯, D♯, A♯, E♯, B♯) and flats go down by fifths (B♭, E♭, A♭, D♭, G♭, C♭, F♭).

If you see a piece of music without flats or sharps in the key signature the piece is either in CM or Am or it may be a 20th-century piece that may not be in a key at all (atonal). We never use double flats or double sharps in key signatures which means that there are no pieces that begin keys such as G♯M, which would have an F double sharp, although it is possible that a composer might move to that key after starting in one of the keys listed in Example 3-3.

Example 3-3. Key Signatures

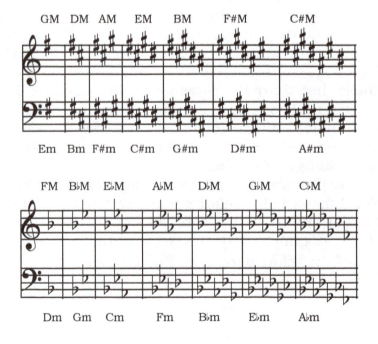

You may have already noticed that the keys as shown above, like their key signatures, are related by perfect fifth up for sharp keys and perfect fifth down for flat keys. As will be seen below, all the keys may be arrayed around a circle that has twelve positions representing each step of the chromatic scale and a scale built on that note. This array is known as the Chromatic Circle of 5ths.

The Chromatic Circle of 5ths

For almost three centuries the twelve steps of the chromatic scale and the keys that are based on them have been arrayed around a circle much like the face of a clock. This was designed as a mnemonic device to bring order to the perplexing world of multiple keys. This arrangement allows us to see the progression of key signatures from no flats and sharps at the twelve o'clock hour to increasing numbers of accidentals toward the bottom of the circle. In Example 3-4 the major keys are outside the Chromatic Circle of 5ths (CC5) and the minors are inside. Traditionally, the sharp keys have been placed on the right side of the circle but for reasons that will be made clear later we will reverse that process in this text. You should study the numbers indicating the quantity of flats or sharps in the key. The hours of 5, 6, and 7 contain keys that are **enharmonic equivalents** because they are spelled differently but sound the same.

Example 3-4. The Chromatic Circle of 5ths

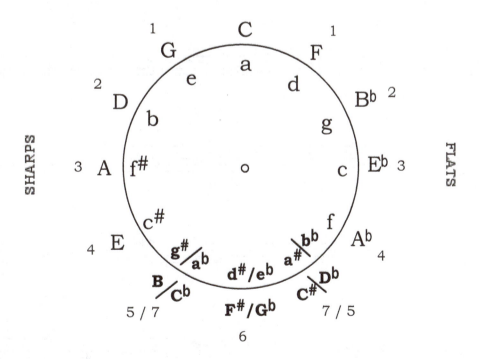

MAJOR SCALES

There are fifteen major scales, each one starting on a different note of the chromatic scale plus some enharmonics. Here are the ones you will enjoy using early in your career because they have the fewest accidentals (flats and sharps). They all have the same structure. The pattern of whole and half steps is identical in each one: W W H W W W H. The name of the scale is derived from the first note, so the first scale is known as the C major scale. Read these scales aloud, then sing them, then write them, then play them on your keyboard. Memorize these scales for they are the foundation of everything you need to know about music theory. On a separate sheet of music paper write these scales up and down.

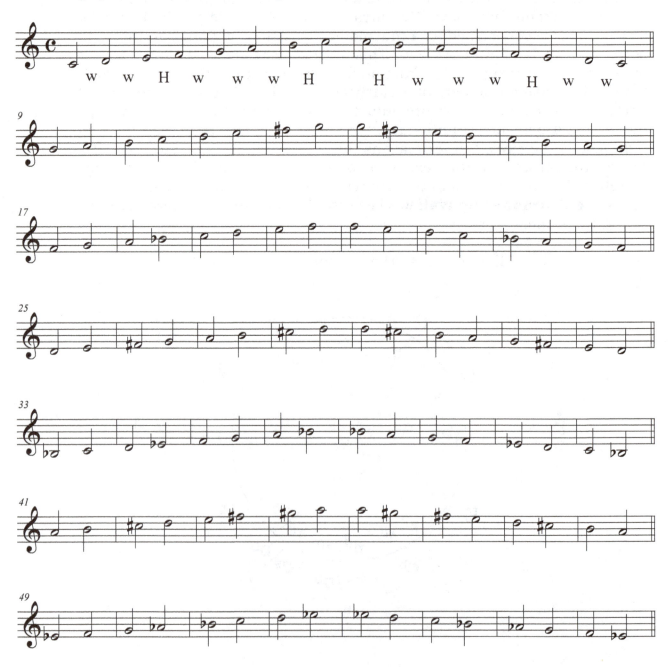

THE OTHER MAJOR SCALES

Here are the scales with more than three flats or sharps. There are no easy scales
or hard scales, just scales you know and those you do not know. For example,
F major has one flat and F# major has one natural. How easy is that? Get familiar
with all of them and your life as a musician will be easy.

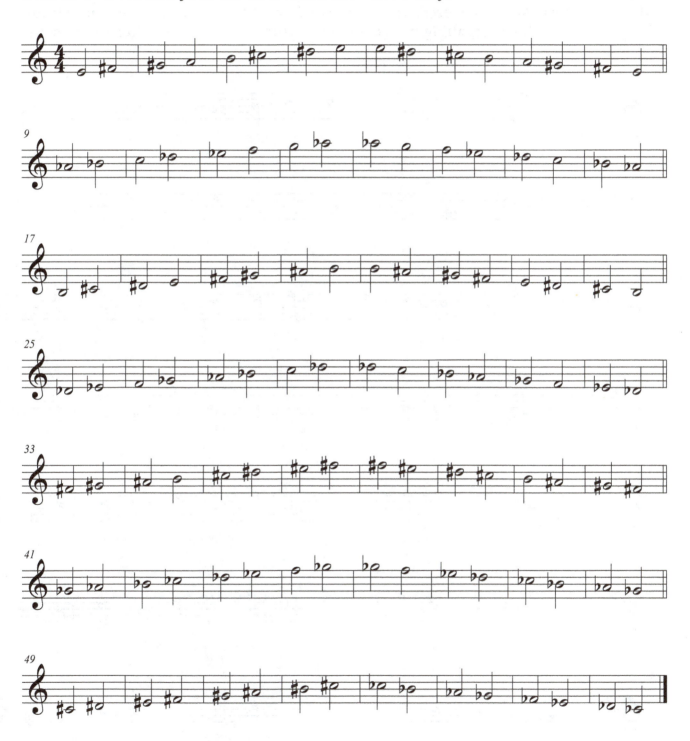

KEY SIGNATURES

In order to save time and ink composers through the ages have used key signatures
to indicate the scale they are using and to save having to write the accidentals every
time they appear in the music. The key signature is a collection of flats or sharps
that appear at the begging of every line of music. If you see an F sharp in the key
signature it means that every time you see the note F is must be played or sung as F#.
Memorize these key signatures. They will be the key to your success as a musician.
It is interesting how beginning musicians forget the key signature after three measures.

THE SHARP KEY SIGNATURES

Here are the sharp scales. Please notice that the sharps always appear in the same order. Sharps go up by perfect 5ths and down by perfect 4ths. Write the appropriate accidentals next to the notes in the scale.

THE SHARP KEY SIGNATURES

BASS CLEF

Here are the sharp scales. Please notice that the sharps always appear in the same order. Sharps go up by perfect 5ths and down by perfect 4ths. Write the appropriate accidentals next to the notes in the scale.

THE FLAT KEY SIGNATURES

Here are the flat scales. Please notice that the flats always appear in the
same order in the key signature. Flats go up by perfect 4ths or down by perfect 5ths.
Write the appropriate accidentals next to the notes in the scale.

THE FLAT KEY SIGNATURES

BASS CLEF

Here are the flat scales in the bass clef. Please notice that the flats always appear in the same order in the key signature. Flats go up by perfect 4ths or down by perfect 5ths. Write the appropriate accidentals next to the notes in the scale.

WRITING MAJOR KEY SIGNATURES

Write the major key signatures:

F major B♭ major E♭ major A♭ major D♭ major

G♭ major C♭ major G major D major A major

E major B major F♯ major C♯ major

MAJOR SCALES QUICK TEST 1

Print Your Name _____

Put the proper accidentals next to the appropriate scale steps.

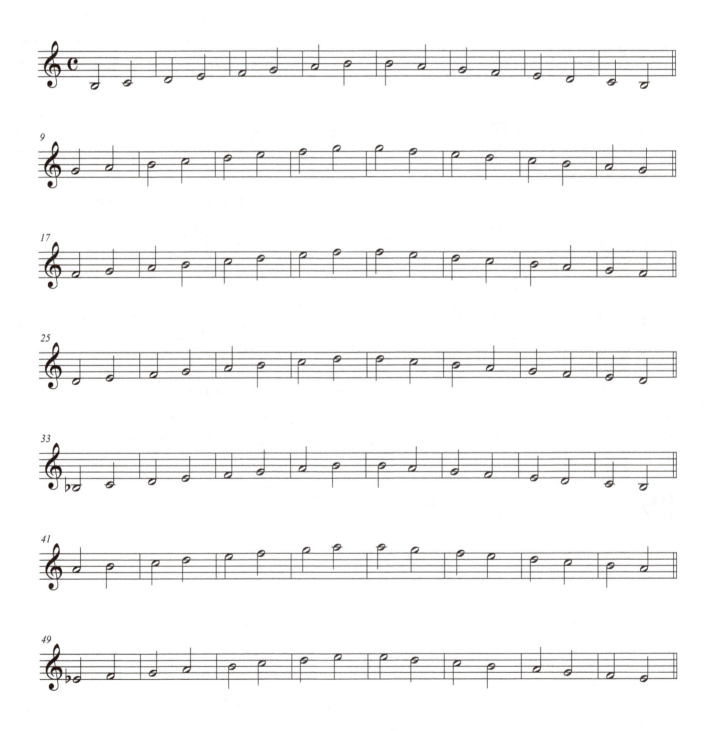

MAJOR SCALES QUICK TEST 2

Print Your Name _____

Put the proper accidentals next to the appropriate scale steps.

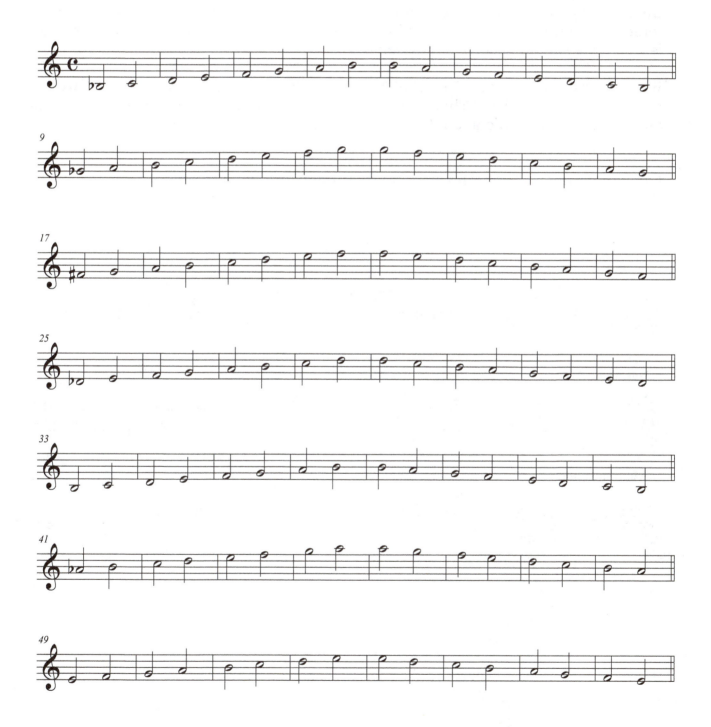

APPRECIATING MINOR SCALES

There is only one version of the major scale but there are three versions of the minor scale. For a variety of reasons both musical and practical, musicians over time have used a few modifications to what once was the ancient Greek scale known as the Aeolian mode. We now call that scale "natural minor." Because this scale has no leading tone one is often added when a dominant harmony resolves to the tonic. When we add an accidental to make scale step 7 a half step below the tonic we call that the "harmonic minor scale." It has an exotic feel to it because there is now an augmented second between 6 and 7.

When we raise both 6 and 7 on the way up and lower them on the way down we call that "melodic minor." This scale resulted from a natural tendency to raise pitches as they rise to the tonic and fall as they descend to the dominant.

Label the intervals between notes in order to discern the differences.

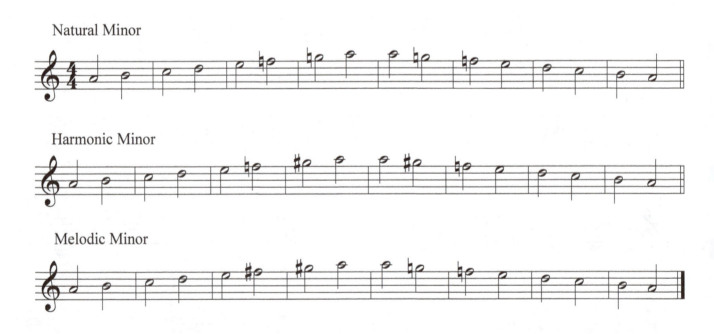

NATURAL MINOR SCALES

There are fifteen natural minor scales. Here are the ones you will enjoy using early in your career because they have the fewest accidentals (flats and sharps). They all have the same structure. The pattern of whole and half steps is identical in each one: W H W W H W W. The name of the scale is derived from the first note, so the first scale is known as the A natural minor. Read these scales aloud, then sing them, then write them, then play them on your keyboard. Memorize these scales for they are the foundation of everything you need to know about music theory.

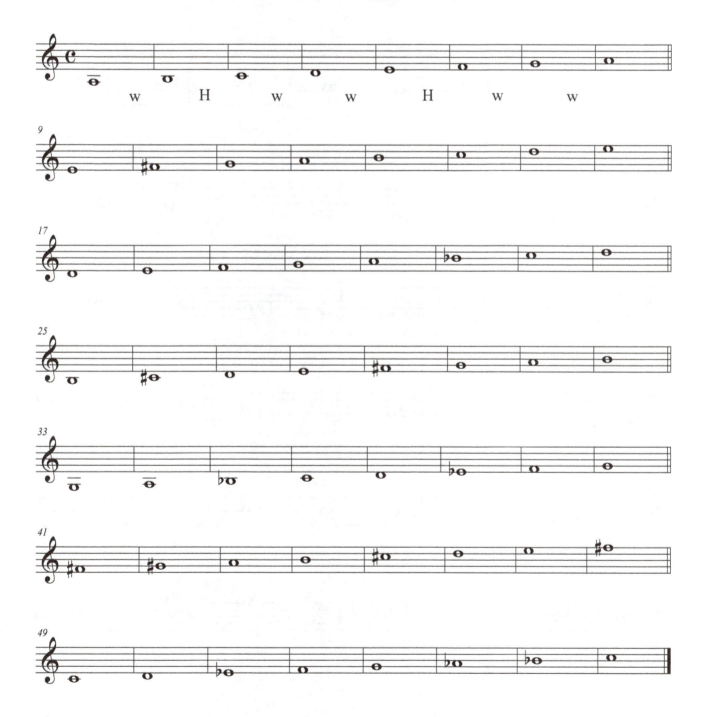

THE OTHER NATURAL MINOR SCALES

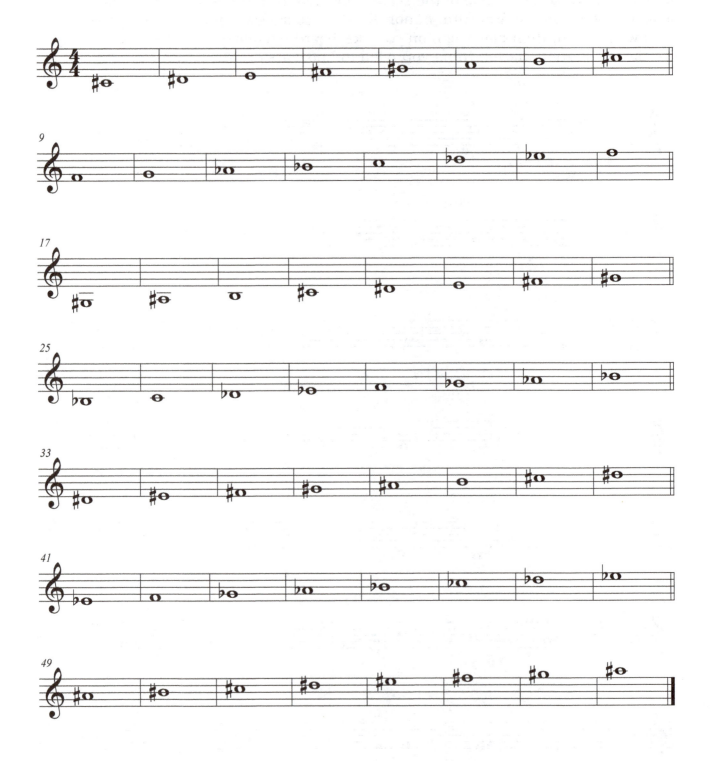

MELODIC MINOR SCALES

Write the melodic minor scales starting with the given notes.

A melodic minor

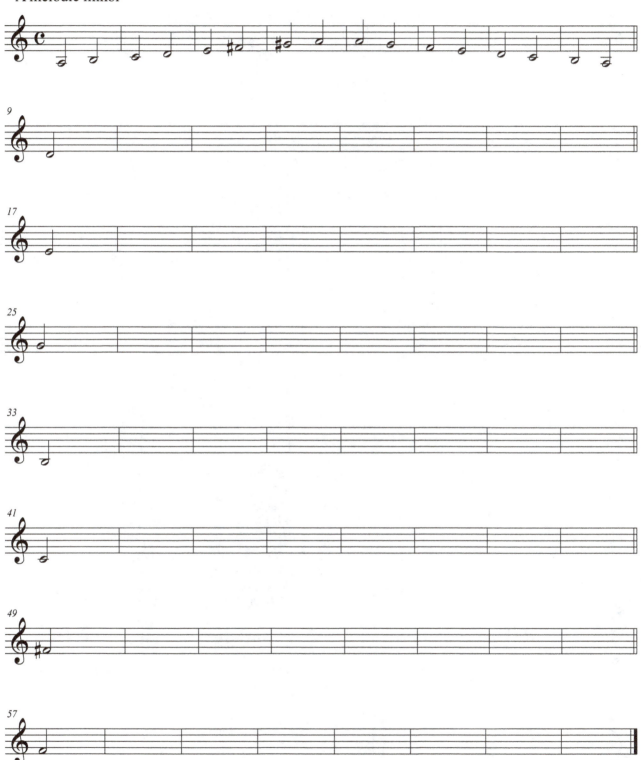

HARMONIC MINOR SCALES

Write the harmonic minor scales starting with the given notes.

A harmonic minor

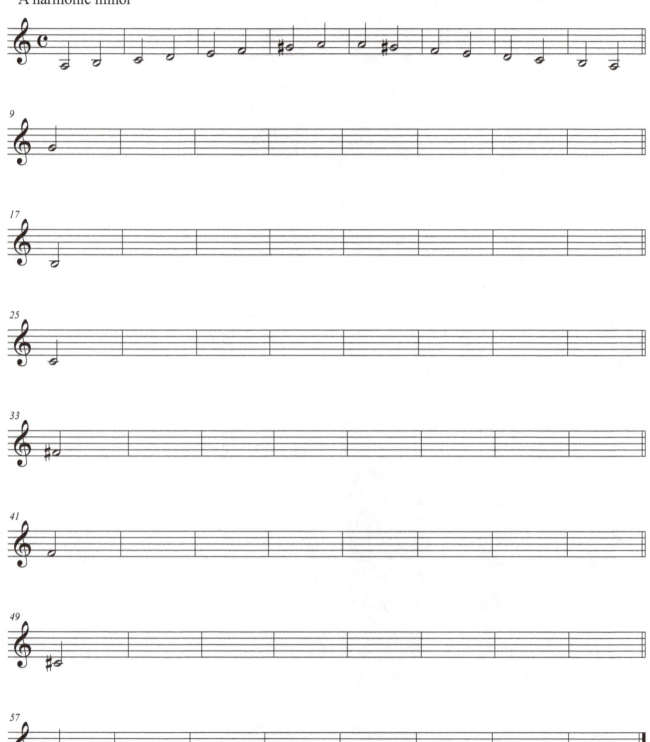

WRITING MINOR KEY SIGNATURES

Write the minor key signatures:

D minor G minor C minor F minor B♭ minor

E♭ minor A♭ minor E minor B minor F♯ minor

C♯ minor G♯ minor D♯ minor A♯ minor

SCALAR ADVENTURES

This piece is very conjunct, moving almost entirely by stepwise motion.
First sing the piece with numbers and then play it one hand at a time.
When this is well in hand transpose it to another key. Practice daily.

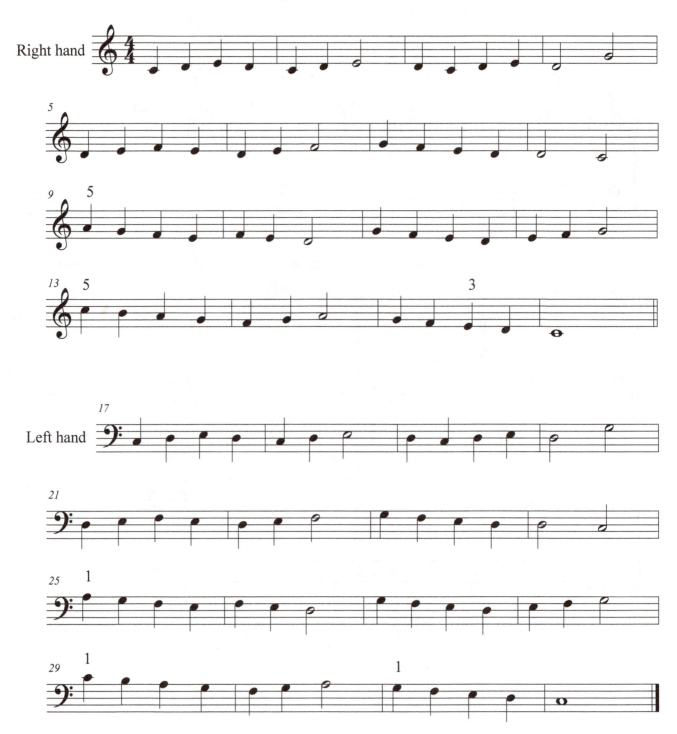

SCALE FINGERING CHART

Over the ages there have been many approaches to proper keyboard fingering. There is no right or wrong fingering because the size and shape of hands are different from person to person. Below is a chart of recommended fingerings, but you may find that there are alternatives more comfortable for you. In any case, here are a few simple rules that are almost universally accepted:

1. The thumb never plays a black note.
2. The fourth finger usually plays a black note when one exists in the scale.
3. The pinky may be used at the beginning or end of a scale, or at a turn-around.

These are the scales that you should be able to play smoothly and comfortably by the end of the semester: one octave, one hand at a time. Sometimes we use different fingering patterns when playing only one octave instead of two or more. Here are easy one-octave patterns.

MAJOR KEY	HAND	FINGERING	MINOR KEY	HAND	FINGERING
C major	Right	12312345	A minor	Right	12312345
	Left	54321321		Left	54321321
G major	Right	12312345	E minor	Right	12312345
	Left	54321321		Left	54321321
F major	Right	21231234	D minor	Right	12312345
	Left	32143212		Left	54321321
D major	Right	54321321	B minor	Right	12312345
	Left	54321321		Left	43214321
B@ major	Right	21231234	G minor	Right	12312345
	Left	32143212		Left	54321321
A major	Right	12312345	F# minor	Right	23412345
	Left	54321321		Left	43214321
E@ major	Right	21234123	C minor	Right	12312345
	Left	32143212		Left	54321321
E major	Right	12312345	C# minor	Right	23123123
	Left	54321321		Left	32143212
A@ major	Right	23123123	F minor	Right	21231234
	Left	32143212		Left	54321321

CHAPTER 4

MEASURING WITH INTERVALS

An interval is the distance between two tones. Everything we do in music relates to intervals whether harmonic (simultaneous) or melodic (consecutive). It is, therefore, extremely important that you become proficient in calculating intervals before beginning the further study of music theory. As you saw in the previous chapter we may use a scale as a measuring stick to calculate the size of certain intervals. Example 4-1 shows all of the practical intervals within an octave as well as a few commonly used **compound intervals** (larger than an octave). When working with compound intervals it may sometimes be easier to reduce them to simple form by subtracting 7 from the interval number. For example, M10 = M3; P12 = P5; P15 (two octaves) = P8 or P1.

Example 4-1. Intervals

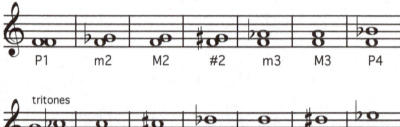

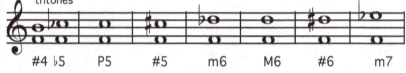

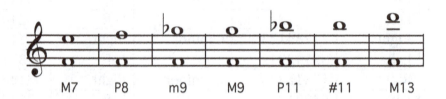

For purposes of abbreviation we will use a capital M for major intervals, lowercase for minor, a sharp for augmented, and a flat for diminished.

Some intervals are **enharmonic** because, although they may be written differently, when played or sung they sound the same. For example, the augmented 6th and the minor 7th are enharmonic.

Intervals may be grouped into three classes according to their effect on the listener. Primes, octaves, fourths and fifths are **perfect consonances** and seem to share a distinct quality of sound. Thirds and sixths are **imperfect consonances** and to our ears sound harmonic. Seconds, sevenths, and tritones (written as either ♯4 or ♭5) are **dissonances** whose tension seems to beg for resolution to an interval that is more pleasing.

When dealing with intervals, **inversions** are often a consideration. To invert an interval, take the lower note and raise it an octave, thereby making it the upper note. To quickly calculate the inversion of an interval, subtract the interval number from 9. All minor intervals invert to major, major intervals to minor, a diminished to an augmented, an augmented to a diminished, and a perfect to a perfect. Here are the inversions of intervals smaller than an octave:

m2 inverts to a M7

M2 inverts to a m7

aug2 inverts to a dim7

m3 inverts to a M6

M3 inverts to a m6

P4 inverts to a P5

aug4 inverts to a dim5

MEASURING INTERVALS

The distance between two notes is known as an interval. We measure this distance using a scale. For example, the interval between C and D is known as a second because D is the second note of the C major scale. All intervals have two names-- one tells the quality and the other tells the scale step. If you are measuring an interval using a major scale then you end up with the intervals shown on the first staff below. The intervals derived from minor and other scales are shown on the second staff. These interval measurements can begin on any note of the chromatic scale. Play these intervals on your keyboard to hear how each one sounds. Each interval has a different character. They serve as the foundation of all harmony. You will need to be able to recognize intervals with speed an accuracy if you want to succeed as a musician. For added appreciation, play the note C on your keyboard and sing the rising and falling major scale against it. Then try the chromatic scale.

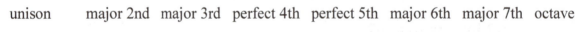

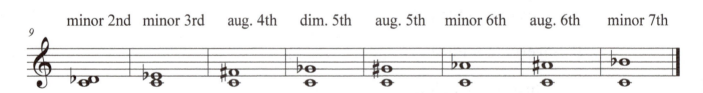

KEY INTERVALS

Here are all the intervals contained within C major and C natural minor. When you have this mastered try it in other keys. Feel free to sing while you play. Play each hand separately, then both together.

Major

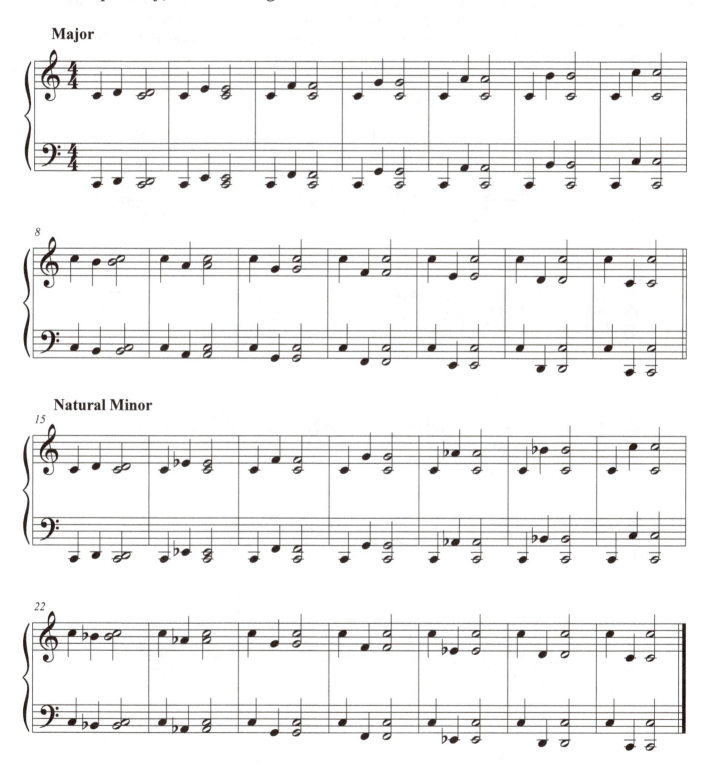

Natural Minor

NAME THE INTERVALS

TREBLE CLEF

There are thirty intervals below. See how many you can identify correctly in six minutes. Keep practicing until you can do them all in three minutes. Write the names above the interval as shown. Playing these on your keyboard will also help your ear to identify them.

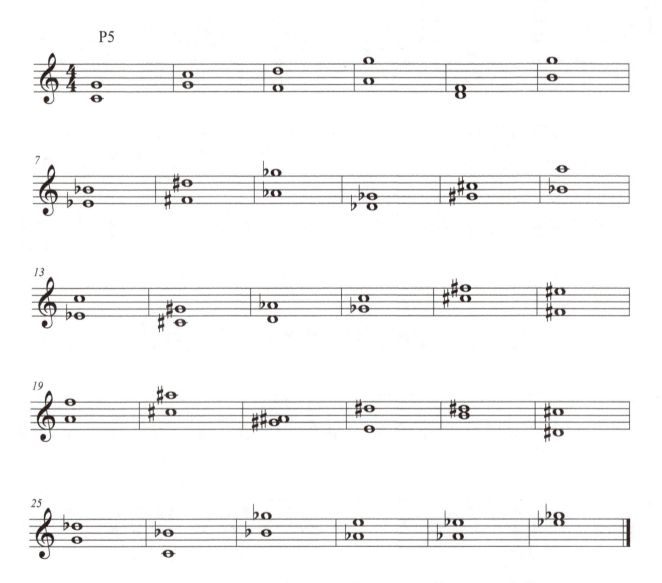

NAME THE INTERVALS

BASS CLEF

There are thirty intervals below. See how many you can identify correctly in six minutes. Keep practicing until you can do them all in three minutes. Write the names above the interval as shown.

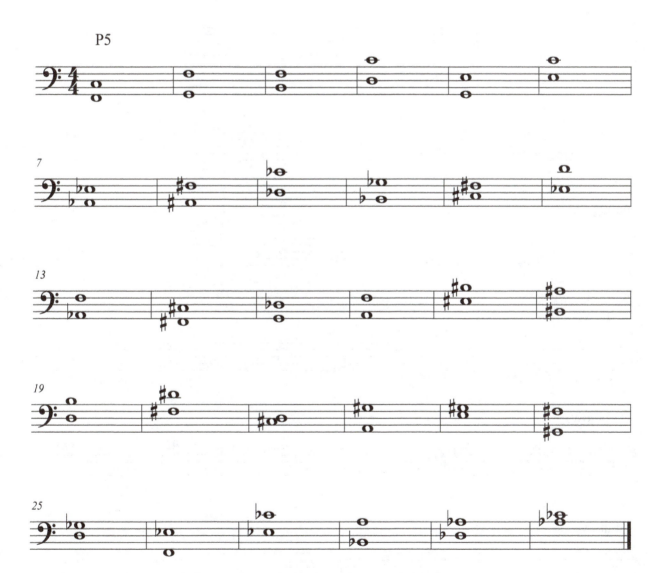

PRACTICING INTERVALS

PERFECT 4THS AND 5THS

Write the intervals indicated on each line.

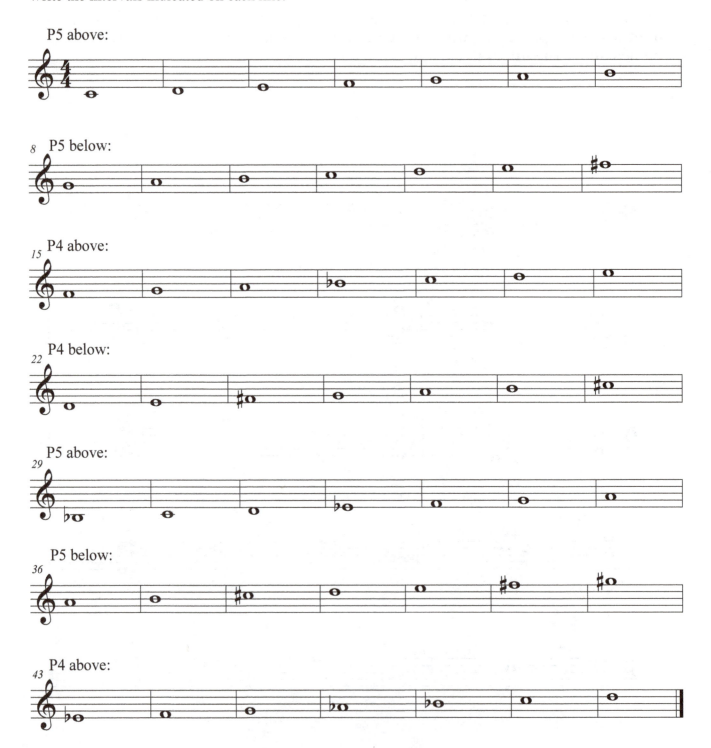

PRACTICING INTERVALS

MINOR 3RDS AND MAJOR 6THS

Write the intervals indicated on each line.

M6 above:

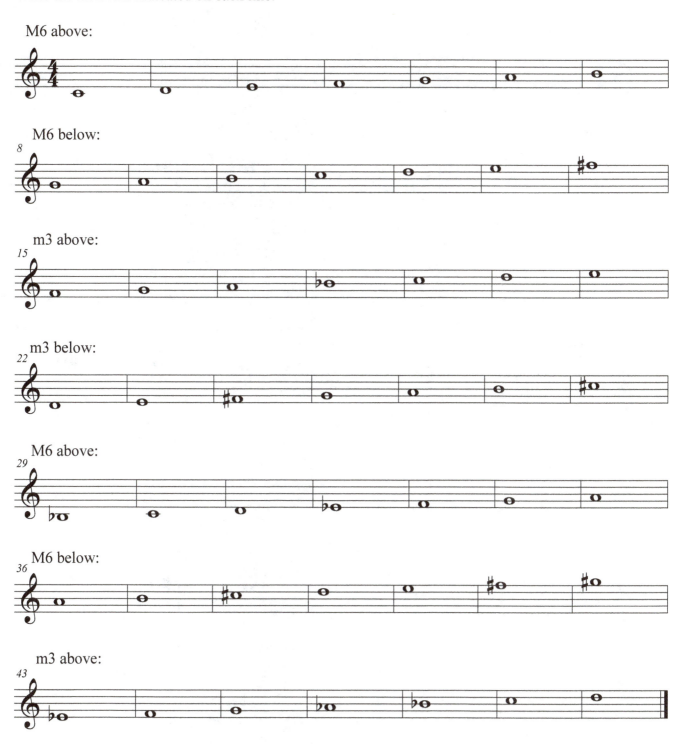

M6 below:

m3 above:

m3 below:

M6 above:

M6 below:

m3 above:

PRACTICING INTERVALS

MINOR 2NDS AND MAJOR 7THS

Write the intervals indicated on each line.

M7 above:

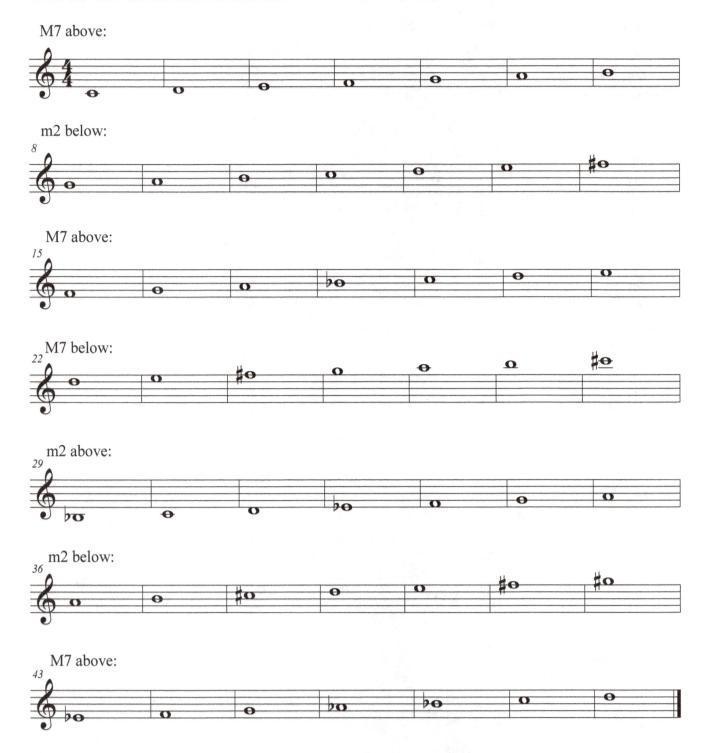

m2 below:

M7 above:

M7 below:

m2 above:

m2 below:

M7 above:

PRACTICING INTERVALS

MAJOR 2NDS AND MINOR 7THS

Write the intervals indicated on each line.

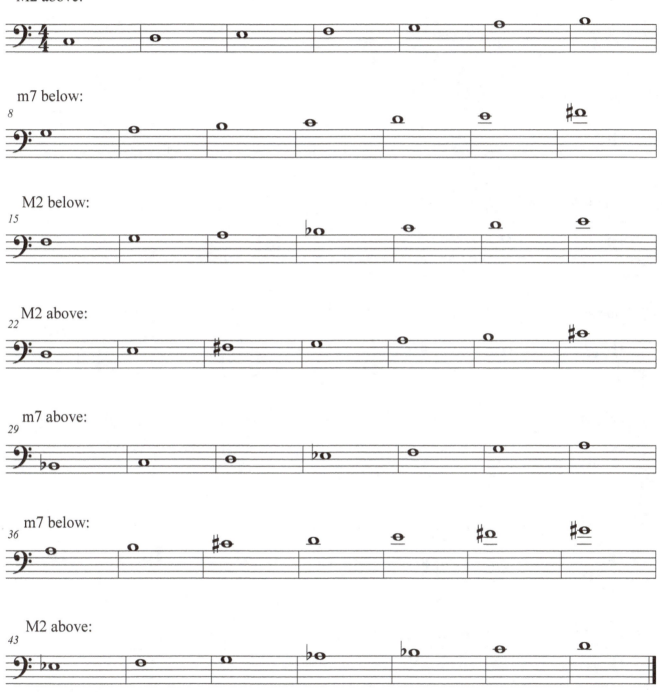

PRACTICING INTERVALS

MAJOR 3RDS AND MINOR 6THS

Write the intervals indicated on each line.

M3 above:

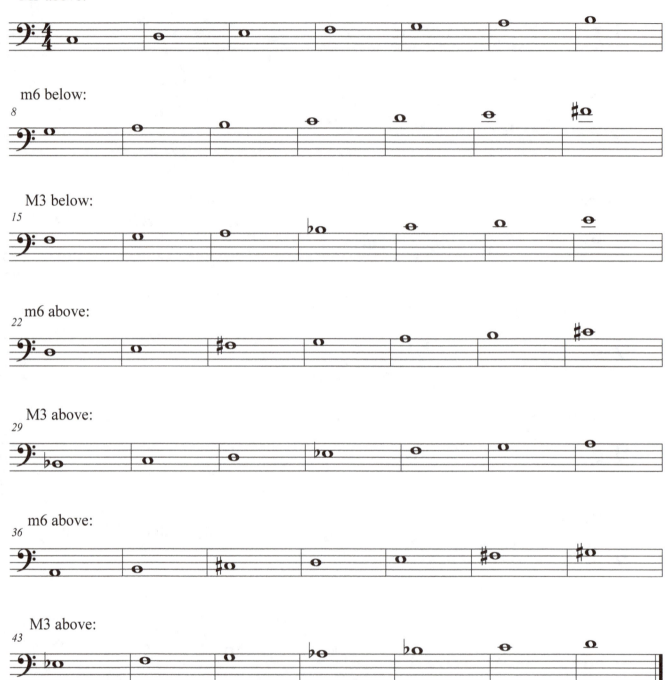

m6 below:

M3 below:

m6 above:

M3 above:

m6 above:

M3 above:

PRACTICING INTERVALS
AUGMENTED 4THS AND DIMINISHED 5THS

Write the intervals indicated on each line.

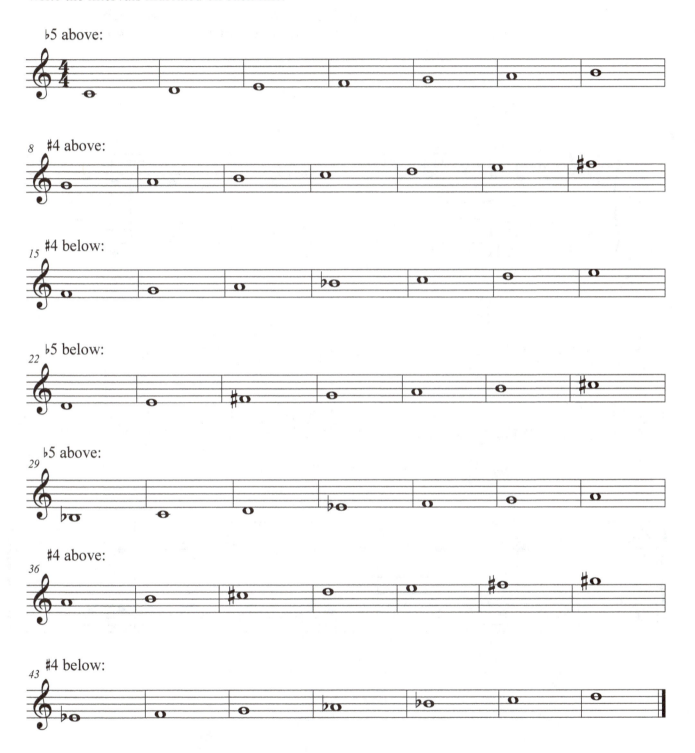

GOING TOGETHER

Stephen Jablonsky

Look this 5-finger piece over and indentify the intervals between the two voices. Then play it on your keyboard, slowly at first, then as fast as you can without mistakes.

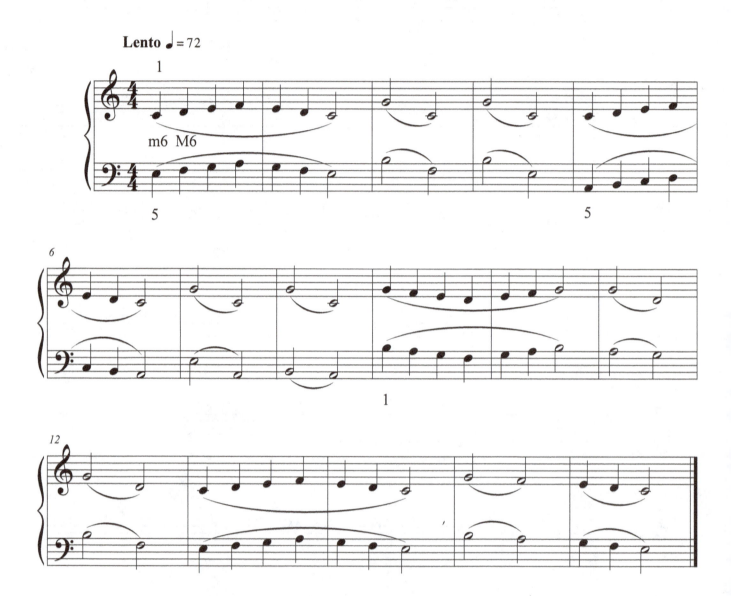

CHAPTER 5

HARMONIZING WITH TRIADS

The construction of triads

An interval consists of two notes played simultaneously or consecutively. A **chord** is a discrete collection of three or more notes that function as a harmonic unit. Its constituents may be played simultaneously or consecutively. Most of the time we see or hear all the notes of a chord in close proximity to each other, but other times we are presented with incomplete harmonic information. In other words, composers do not always use all the notes all the time.

The basic harmonic unit in tonal music is the **triad**, a three-note chord built of 3rds. Harmony based on 3rds is labeled **tertian** (i.e., every other note in scalar motion). The note on which the chord is built is called the **root**; another note is added a 3rd above the root and is called the **third**; the other member of the chord lies a 5th above the root (and a 3rd above the third) and is called the **fifth** (see Example 5-1, root position). In every triad there are three intervallic relationships: between the bottom note and the middle note, between the bottom note and the top note, and between the middle note and the top note. Each of these intervals contributes to the way your brain processes the aural data it receives, but the intervals measured from the bottom are the most critical because the lowest sounding note is the harmonic foundation.

A triad may appear with any of its three notes in the lowest position we call "the **bass**." We use this appellation even though it may not actually be in the bass voice or bass clef. When the root is lowest, the triad is most stable and is said to be in **root position**. As such we have 3rds between each of the notes and a 5th between the root and the top note. It is important to remember that the root is not always the same as the bass (the lowest sounding note). The root and bass are the same only in root position.

If we rearrange the triad, making the third the lowest note and the root the top note, the triad is in **first inversion**. In this position there is a 3rd between the bass and the middle note, a 6th between the bass and the root, and a 4th between the middle note and the root. This is a different collection of intervals than that found in root position. They both have the same root but provide the

listener with two different aural experiences. In this inversion the triad is somewhat less stable than it was in root position.

When the fifth is lowest, the triad is in **second inversion**. The special sound of the second inversion results from the 4th between the bass and the root, the 6th between the bass and the third, and the 3rd between the root and the third. Later, we will see that the fourth between the bass and the root creates a sonority that is quite unstable and must be handled with care.

Example 5-1. Inversions of Triads

root position first inversion second inversion

 (5) 6 6
 (3) (3) 4

In Example 5-1, the intervals above the bass are indicated for each position of the triad. This practice is known as **figured bass** in which the Arabic numerals serve as a convenient shorthand label for each form. This system, also known as **thoroughbass**, was essential to the instrumental chamber music of the Baroque Period during which the harpsichord player, as accompanist, often had the bass line and Arabic numerals and was expected to improvise the rest of the texture based on the information provided. In their most common form triads are abbreviated as follows:

> (root position) is assumed and is not notated;
> (first inversion) is abbreviated as 6;
> (second inversion) is notated as 6/4.

Triads in other arrangements

The triad is not always presented with all of the notes within an octave, called **close position**, as in Example 5-1 above. Sometimes chords appear in **open position**, with the notes farther apart (more than an octave). Triads must always be made from letter combinations of root, 3rd, and 5th regardless of the accidentals used. For example, a C minor triad is comprised of the notes C, Eb, and G, never C, D#, and G. Only the following combinations are possible (practice reciting these combinations to assure accuracy):

<center>A-C-E B-D-F C-E-G D-F-A E-G-B F-A-C G-B-D</center>

Therefore, whenever you see a chord that is in open position, or jumbled up, all you need to do is match what you see to the seven combinations above.

> Here is an interesting question: How many C triads are there on the piano keyboard? In other words, how many combinations of C, E, and G are there?
>
> The answer is 392. There are eight Cs, seven Es, and seven Gs. 8 x 7 x 7=392. Wow!

The four types of triads

There are four types (qualities) of triads whose names depend on the interval between the root and 3rd and interval between the root and 5th:

<center>Table 5-1. How Triads Are Labeled</center>

When the 3rd is	And the 5th is	The quality is
minor	diminished	*diminished*
minor	perfect	*minor*
major	perfect	*major*
major	augmented	*augmented*

In Example 5-2 we see the four types of triads built on the root G. Only major and minor triads may be used as tonics. The diminished triad only appears as iiº, viº, and viiº while the augmented triad is occasionally used as an altered form of the dominant.

<center>Example 5-2. Types of Triads</center>

Using chord symbols to name triads

Every triad has two names—the name of the root and the name of the quality. Thus, a major triad with a root of G is named "G major" and is notated by the capital letter G. For major triads it is not necessary to indicate the quality in the label—if we see just the letter G we will know it refers to G major. A minor triad with a root of G is named "G minor" and is notated as Gm. Use "+" for augmented (or "aug") and "o" for diminished (or "dim"). Do not use the archaic system that assigns a plus (+) to major and a minus (-) to minor. The minuses that students write on their homework and test papers tend to get too small to read clearly and the negative appellation is an inappropriate value judgment.

Chord inversions can be notated by adding the bass pitch after a slash. For example, Am/C indicates an A minor triad with C in the bass (first inversion). This use of chord symbols is called **lead sheet notation** and is common in popular sheet music and jazz scores and is always written above the chord (Example 5-3). The simplest lead sheet scores do not contain information about inversions, but you would do well to use the slashes when appropriate because the bass line is so important in tonal music.

Example 5-3. *America* (opening)

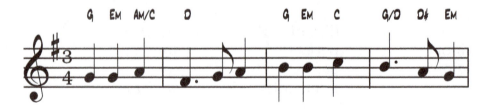

Numbering the triads

We use **Roman numerals** to identify the scale step on which the triad is built and **Arabic numerals** to indicate the inversion. In this text the Roman numerals will appear in uppercase to represent major and augmented triads and in lowercase for minor and diminished. Thus, a C major chord in first inversion (with E in the bass) in the key of C major is labeled I⁶. The Roman numeral "I" indicates that the root of the triad (C) is the first note (tonic) of the key (C major). The Arabic numeral "6" indicates that the triad is in first inversion—that there is a 6th between the bass and the root.

Note that the lead sheet name is the same no matter what key the triad is in. (Cm is the label for C-E♭-G whether it is the tonic in C minor, the submediant in E♭ major, or the subdominant in G minor. Note, also, that the same scale degree indicates a different triad in different keys (e.g., a I chord in CM is a C major triad, but a I chord in FM is an F major triad). In Example 5-4 we see

that the same three triads are labeled differently according to the key in which they are found.

Example 5-4. Examples of Chord Labels

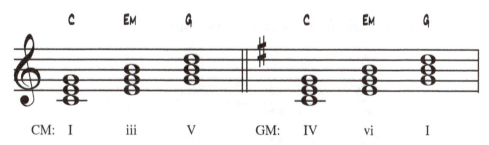

It is essential to know both systems of notation thoroughly and to be able to translate from one system to the other rapidly. Whereas lead sheet notation treats all chords as isolated units without regard to key, the numbered scale step notation relates the chords to one another and also indicates their functions within the tonal system of a particular key.

To translate lead sheet notation into scale step notation, use a Roman numeral for the scale step of the root of the triad. Indicate the quality of the chord by the use of upper or lowercase. Then, add figured bass notation where necessary to show inversions. For example, the first chord in Example 5-5 is G major. In the key of GM a G major triad is I. The second chord, Em, is vi in GM. The third chord is Am/C, the supertonic in the first inversion (ii⁶).

Example 5-5. *America* (opening)

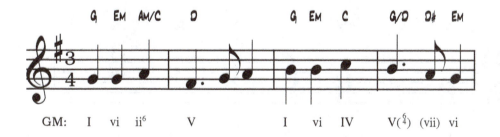

A note about labeling

When using scale step notation, write the Roman numeral only under the beat on which the chord first appears. It is not necessary to repeat the Roman numeral if the chord is repeated. As a general rule, try to write as little as possible to keep your labeling easy to read. If the inversion changes on such a

repetition, change only the figured bass notation—the purpose being to reveal the basic harmonic structure as represented by chord "changes" in a legible manner without cluttering the page with redundant notations. In Example 5-6 you will notice that 5/3 is needed under the third chord to show a return to root position.

Example 5-6. Labeling Inversions

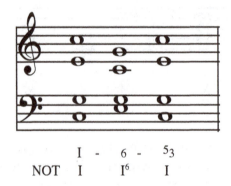

$$I - 6 - {}^5_3$$
NOT I I⁶ I

The quality of triads in major keys

As may be seen in Example 5-7, major keys contain three major triads (I, IV, and V), three minor triads (ii, iii, and vi), and one diminished (vii). This distribution results in a hierarchy of importance. The major chords are the primary triads, the three triads you would learn if you could only learn three chords. There are four secondary chords and the unique one is vii, the only one of this family of chords that is diminished.

Example 5-7. Triad Qualities in Major

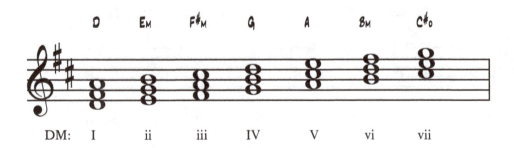

DM: I ii iii IV V vi vii

The quality of triads in minor keys

The family of chords in minor is larger than in major due to the three forms of the minor scale. By comparing the triads in natural minor (Example 5-8) with those in major (Example 5-7) you will notice that in minor the tonic, subdominant, and dominant chords are all minor—the opposite of their

qualities in major. Also, now it is the supertonic that is diminished, not the leading tone (which is replaced by the major subtonic). The mediant and submediant, which were minor, are now major. In many ways, major and minor chord collections seem to present two polarities.

Example 5-8. Triad Qualities in Natural Minor

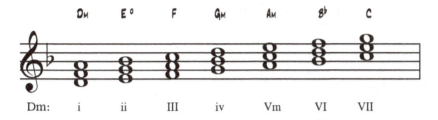

Dm: i ii III iv Vm VI VII

The natural minor scale, formerly known as the Aeolian mode, contains a seventh tone that is a whole step below the tonic. Therefore, dominant harmonies built on that scale do not contain a leading tone and create an archaic "modal" sound, rather than a "tonal" one, when moving to the tonic. The problem of weak dominants is fixed by the addition of the leading tone to V and vii and the result is known as harmonic minor. In a sense, harmonic minor borrows the V and vii chords from major (Example 5-9).

➤ Important advice: Whenever you are about to begin composing a piece in minor you must remind yourself that you will need to add the leading tone in every dominant chord. Make sure you have plenty of accidentals handy. You will need them. If I had a dollar for every time one of my students forgot to add an accidental to a dominant in harmonic minor...

Example 5-9. Triad Qualities in Harmonic Minor

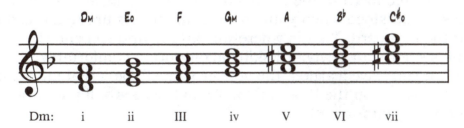

Dm: i ii III iv V VI vii

The need to harmonize the raised 6th and 7th steps in ascending melodic minor creates an interesting admixture of triads that must be employed with great caution. Example 5-10 reveals that the ii, IV, V, and vii are the same as in major. An augmented mediant and a diminished submediant have been added to the harmonic palette and are quite rare.

Example 5-10. Triad Qualities in Ascending Melodic Minor

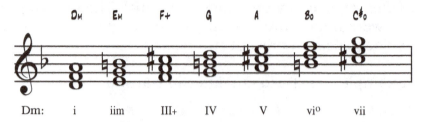

Dm: i iim III+ IV V vi° vii

Program for Tonal Success

Important Advice: It is critical that you *master* scales, intervals, and triads before proceeding any further. Either you build a solid foundation now in your understanding of the fundamentals or you will be struggling ever after. In order to avoid much pain and suffering I recommend the following:

 ♪ Write, say, play, and sing every major and minor scale up and down.

 ♪ Write, say, play, and sing every interval contained in those scales ($\hat{1}$-$\hat{2}$, $\hat{1}$-$\hat{3}$, $\hat{1}$-$\hat{4}$, $\hat{1}$-$\hat{5}$, $\hat{1}$-$\hat{6}$, $\hat{1}$-$\hat{7}$, and their inversions).

 ♪ Write, say, play, and sing every triad and inversion in each family of chords.

Good musicians play the piano. They do not have to be concertizing artists but they do have to be able to know their way around the blacks and whites. Harmony is best understood when your theoretical studies are reinforced by realizations at the keyboard. That is where we can see and feel chord structures. The sooner your keyboard skills allow you to comfortably demonstrate what you have learned, the sooner you will be a real musician. Every minute you spend on the Program for Tonal Success will reap huge dividends later on. I guarantee it!

 ✓ Use a metronome when you practice. It keeps you honest. It also allows you to increase your tempo incrementally.

TRIADS IN MAJOR

Every major key contains a family of seven triads. The tonic, subdominant, and dominant are major. The supertonic, the mediant, and submediant are minor, and the leading-tone is diminished. Label the triads with name and number as shown in C major. Play these on your keyboard every day for good harmonic health.

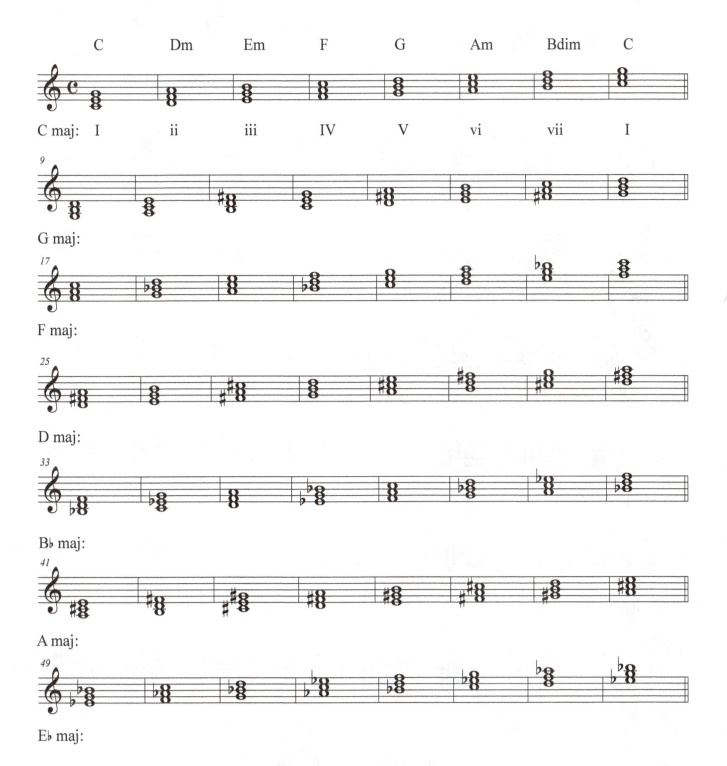

TRIADS IN THE OTHER MAJOR SCALES

Here are the more chromatic keys and their triadic family members.
Label each chord by name and number as shown.

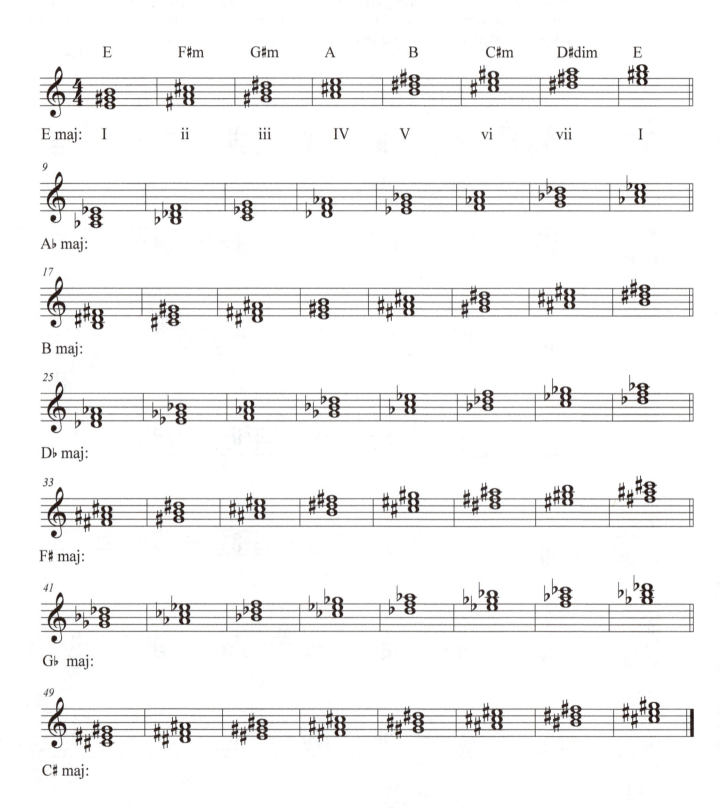

TRIADS IN HARMONIC MINOR

Every harmonic minor key contains a family of seven triads. The tonic and subdominant are minor and the dominant is major. The mediant and submediant are major while the supertonic and leading tone are diminished. Label the triads with name and number as shown in A minor.

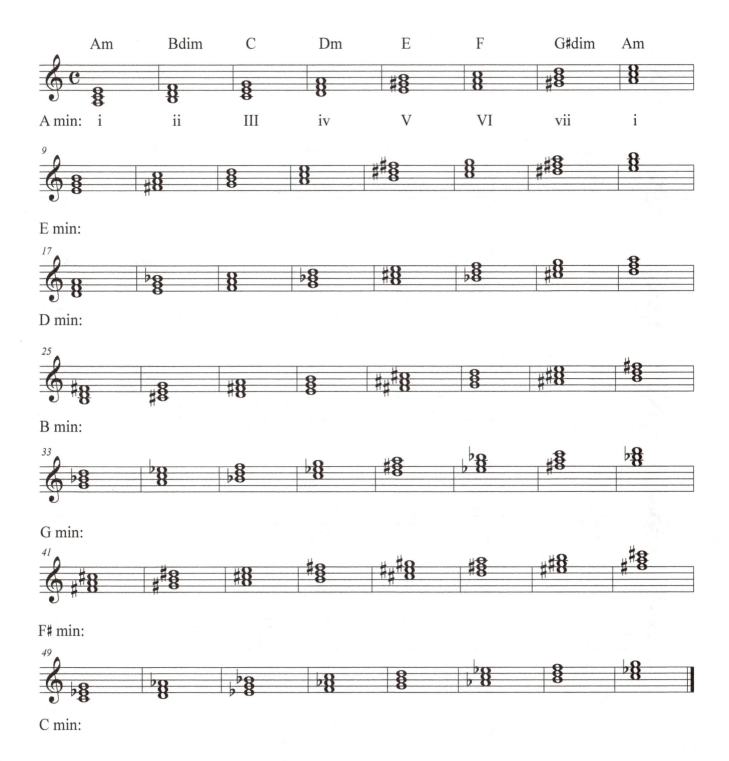

PRACTICE WRITING TRIADS

Write the triads as indicated. Remember, neatness counts.

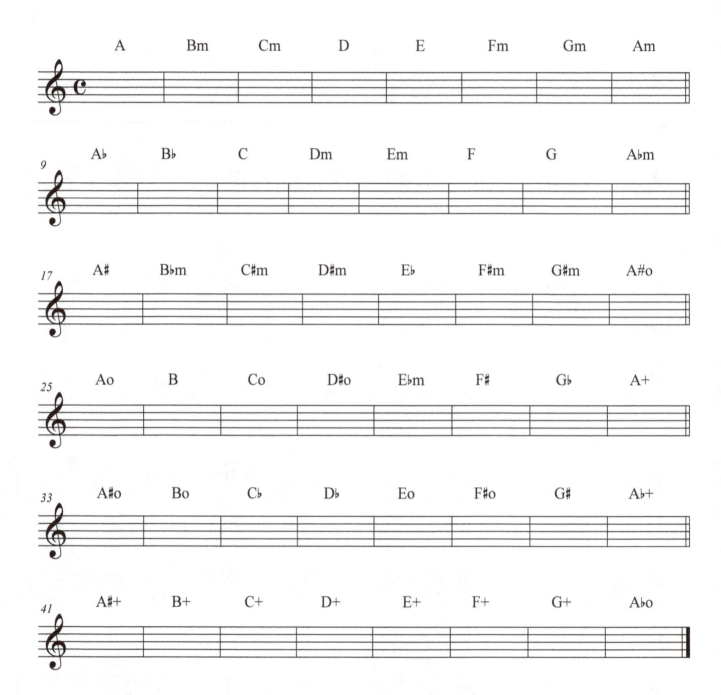

IDENTIFYING TRIADS

Write the names of the triads above each chord.

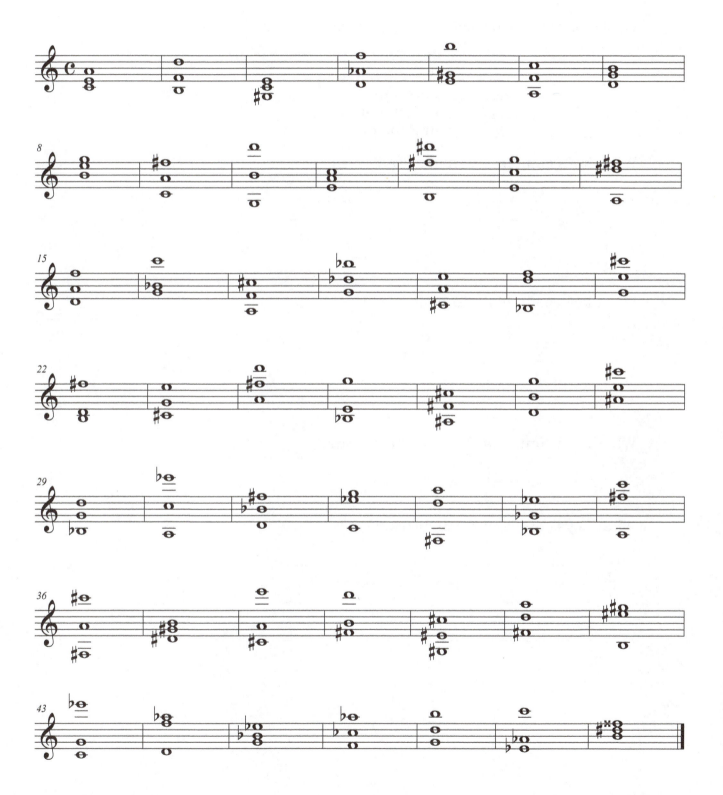

FIND THE KEY 1

What keys contain a D minor triad? Provide the chord function as shown.

1. <u>Tonic</u> in D minor
2. _____ in B♭ major
3. _____ in A minor
4. _____ in C major
5. _____ in F major

What keys contain a C major triad?

1. _____ in _____
2. _____ in _____
3. _____ in _____
4. _____ in _____
5. _____ in _____

What keys contain an E♭ major triad?

1. _____ in _____
2. _____ in _____
3. _____ in _____
4. _____ in _____
5. _____ in _____

What keys contain a B diminished triad?

1. _____ in _____
2. _____ in _____

What keys contain a C minor triad?

1. _____ in _____
2. _____ in _____
3. _____ in _____
4. _____ in _____
5. _____ in _____

FIND THE KEY 2

What keys contain an E minor triad? Provide the chord function as shown.

1. <u>Tonic</u> in E minor
2. _____ in G major
3. _____ in B minor
4. _____ in D major
5. _____ in C major

What keys contain an A major triad?

1. _____ in _____
2. _____ in _____
3. _____ in _____
4. _____ in _____
5. _____ in _____

What keys contain a B♭ major triad?

1. _____ in _____
2. _____ in _____
3. _____ in _____
4. _____ in _____
5. _____ in _____

What keys contain a D diminished triad?

1. _____ in _____
2. _____ in _____

What keys contain a G minor triad?

1. _____ in _____
2. _____ in _____
3. _____ in _____
4. _____ in _____
5. _____ in _____

PRACTICE WRITING Vs AND Is

Write the dominant triad in the first inversion and the tonic in the keys indicated.
Are you tempted to play these at your keyboard?

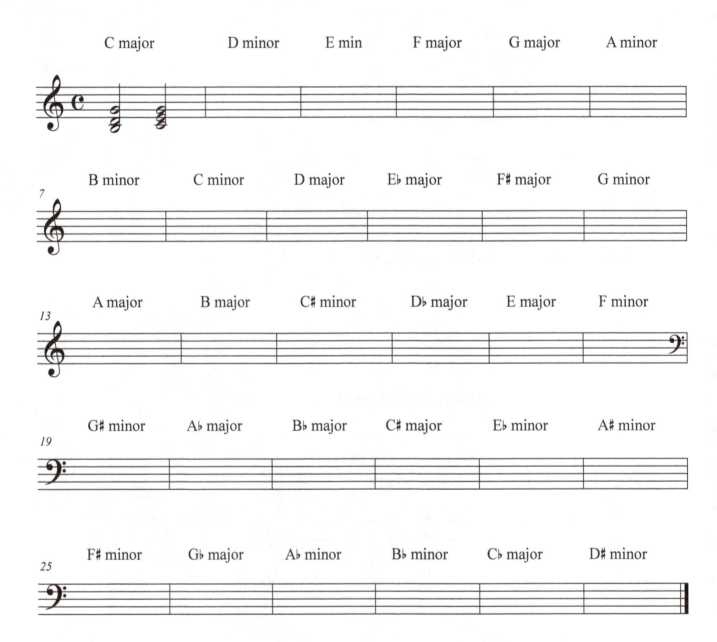

PRACTICE WRITING IIs AND Vs

Write the supertonic and dominant triad in the first inversion in the keys indicated.

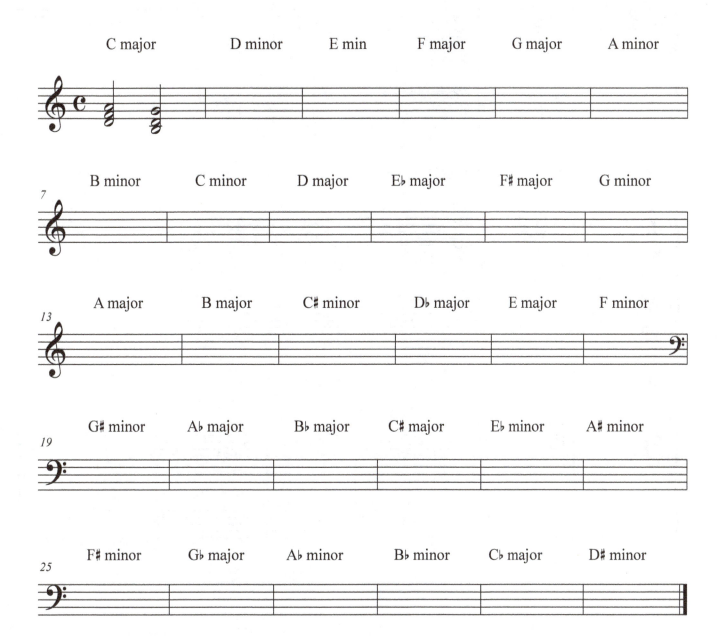

NAME THE TRIADS 1

Write the name of the chord above each measure. For each wrong answer deduct 4 points.
Do not attempt to play this at the keyboard. It could make you hyperchromatic!

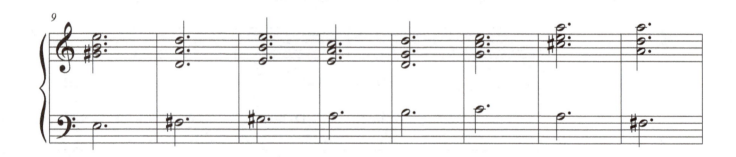

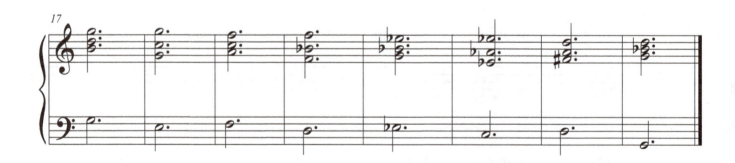

NAME THE TRIADS 2

Write the name of the chord above each measure. For each wrong answer deduct 4 points.
Do not attempt to play this at the keyboard. It could make you hyperchromatic!

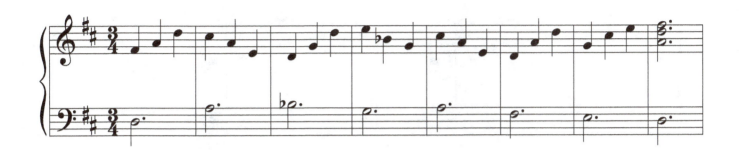

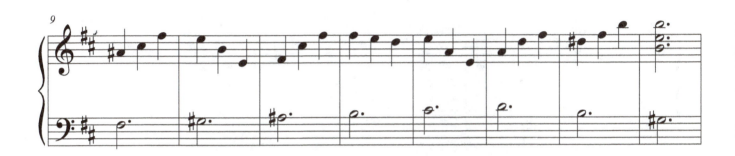

NAME THE TRIADS 3

Write the name of the chord above each measure. For each wrong answer deduct 4 points.
Do not attempt to play this at the keyboard. It is just too hard!

COMPLETING TRIADS 1

| MAJOR | MINOR | DIMINISHED | AUGMENTED |

Write 4 triads that use C as the root.

Write 4 triads that use C as the 3rd.

Write 4 triads that use C as the 5th.

Write 4 triads that use G as the root.

Write 4 triads that use G as the 3rd.

Write 4 triads that use G as the 5th.

COMPLETING TRIADS 2

| MAJOR | MINOR | DIMINISHED | AUGMENTED |

Write 4 triads that use D as the root.

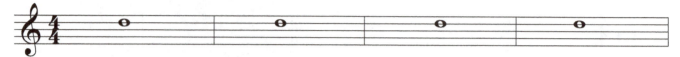

Write 4 triads that use D as the 3rd.

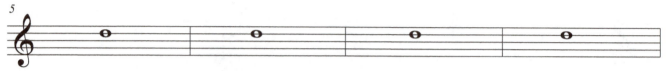

Write 4 triads that use D as the 5th.

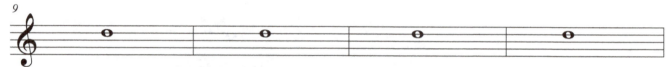

Write 4 triads that use A as the root.

Write 4 triads that use A as the 3rd.

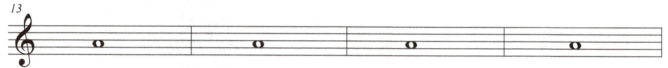

Write 4 triads that use A as the 5th.

COMPLETING TRIADS 3

MAJOR	MINOR	DIMINISHED	AUGMENTED

Write 4 triads that use E as the root.

Write 4 triads that useE as the 3rd.

Write 4 triads that use E as the 5th.

Write 4 triads that use B as the root.

Write 4 triads that use B as the 3rd.

Write 4 triads that use B as the 5th.

COMPLETING TRIADS 4

| MAJOR | MINOR | DIMINISHED | AUGMENTED |

Write 4 triads that use F as the root.

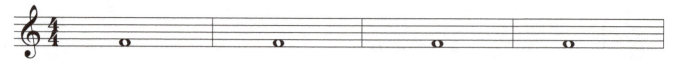

Write 4 triads that use F as the 3rd.

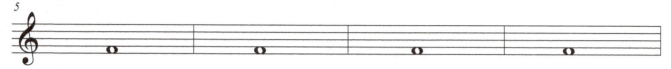

Write 4 triads that use F as the 5th.

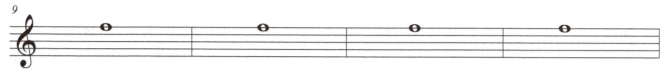

Write 4 triads that use C# as the root.

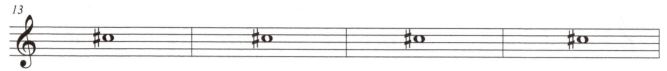

Write 4 triads that use C# as the 3rd.

Write 4 triads that use C# as the 5th.

PRIMARY TRIAD PROGRESSIONS

In the examples below we are using the three primary triads in C major: the tonic (I), the subdominant (IV), and the dominant (V). There are numerous ways to voice these chords but we are starting with a one-hand arrangement that fits easily under the hand. Later you can experiment with other voicings. You need to be able to play these progressions in seven major keys before the semester ends, so get started doing them today. After you have practiced these with one hand feel free to add the note in the other hand.

Sometimes when we play progressions using the primary triads we add a 7th to the dominant harmony. This gives that chord more tension and seems to enhance the resolution to the tonic. It also makes the keyboard fingering easier.

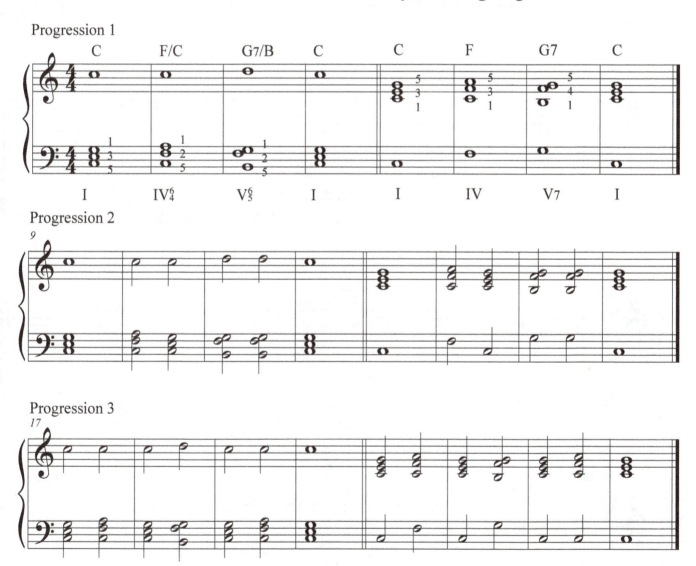

PRIMARY TRIAD PROGRESSIONS
IN OTHER KEYS

Label the chords with names and numbers.
Then write the same primary triad progression in the keys indicated.

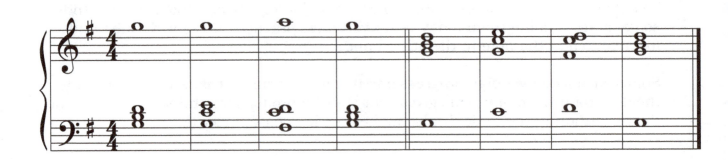

F major

B♭ major

D major

MORE PRIMARY TRIAD PROGRESSIONS
IN OTHER KEYS

Label the chords with names and numbers.
Then write the same primary triad progression in the keys indicated.

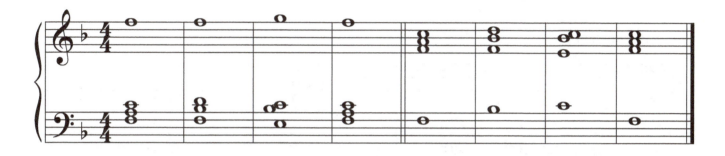

Eb major

A major

E major

USING PRIMARY TRIADS
IN HARMONIC MINOR

Progression 1

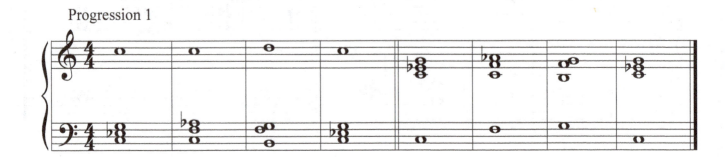

Progression 2

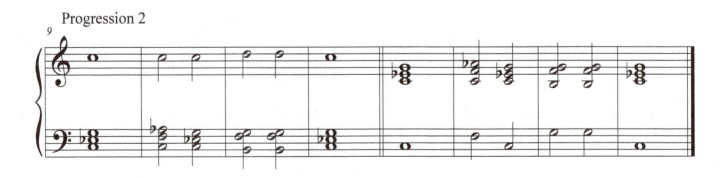

Progression 3

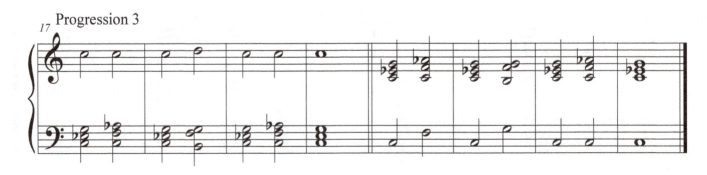

YOU ARE MY MOONSHINE

STEPHEN JABLONSKY

Here is proof that you can compose a perfectly reasonable folk song using using only the three primary triads. Tap the rhythms, sing the tune, and play it on your keyboard.

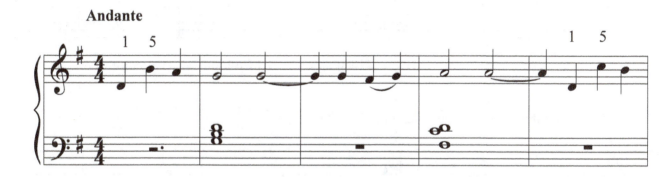

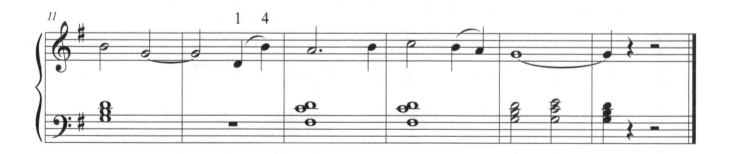

PRACTICE FINAL 1

PRINT YOUR NAME _____

EACH RIGHT ANSWER IS WORTH 3 POINTS. EACH SCALE IS WORTH 14.

Write the key signatures

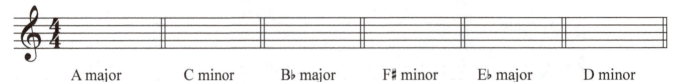

A major C minor B♭ major F♯ minor E♭ major D minor

Write the interval above the given note

major 7th minor 6th dim 5th perfect 5th aug 4th major 6th

Write the triad

A major D minor G minor E dim C aug B minor

Write the interval below the given note

major 6th perfect 5th minor 7th aug 4th major 3rd dim 5th

Write the D harmonic minor scale. Write the E major scale

PRACTICE FINAL 2

PRINT YOUR NAME _____

EACH RIGHT ANSWER IS WORTH 3 POINTS. EACH SCALE IS WORTH 14.

Write the key signatures

| B major | D minor | A♭ major | G♯ minor | D♭ major | B minor |

Write the interval above the given note

| major 7th | minor 6th | dim 5th | perfect 5th | aug 4th | major 6th |

Write the triad

| B major | G minor | C♯ minor | G dim | D aug | F♯ minor |

Write the interval below the given note

| perfect 5th | min 7th | aug 4th | min 3rd | dim 5th | maj 3rd |

Write the E melodic minor scale (up and down) Write the B major scale

CHAPTER 6
SONGS TO BE SUNG

The human voice is the instrument we carry around with us at all times. It is also the means by which we lullaby our children, serenade a lover, or demonstrate national pride. The ability to sing correctly is important for all musicians. Therefore, if you have never had any proper vocal training it might be a good idea to take a voice class early in your studies with us since you will be doing a lot of singing as a music student and later as a musician. The better you sing the easier it will be to perform the many challenges that lay ahead. It might even be fun.

There are two situations in which we sing. There is prepared singing, when you have sufficient time to get a song ready for public performance, and there is sight singing, when you only have a few minutes to prepare a piece you have never seen before.

When sight singing, it is always a good idea to study the demands of the music before you attempt to perform it. Take a few minutes to preview the music. Much of what you see may lie well within your expertise but it pays to identify the difficult areas before you start singing. Locate potential problems relating to rhythms, large skips, or accidentals. Work them out before you perform the entire piece. Start by just singing the rhythms until this element is firmly in place. Then, when you are confident about the rhythms, address pitch problems. Then say the letter names or scale step numbers in rhythm. When that feels strong you are ready to sing. Begin by singing at half speed and then get faster when things are going well.

Some people sing with solfeggio syllables (do, re, mi, fa, sol, la, ti, do) while others use scale step numbers. Singing with numbers will help you with matters of music theory. For notes that are diatonic (in the scale) say: "one," "two," "three," "four," "five," "six," and "sev" for seven. When singing chromatic music, say "sharp" or "flat" for notes that are alterations of scale steps. Before you begin to sing, it is always a good idea to vocalize in the mode of the piece so take a look at page three.

A prepared song is one that is ready to be recorded or performed for an adoring public. Even if you are not a great singer pretend that you are and you might just surprise yourself by how good you sound. So, open your mouth and project your song to the back of the room.

THE ROAD AHEAD

Here is the first page of *Molto Cantabile!*, a sight singing book you might be lucky enough to use in your musicianship classes. This gives you an idea of the challenges that lay ahead. You are working towards being able to sight sing tunes like these.

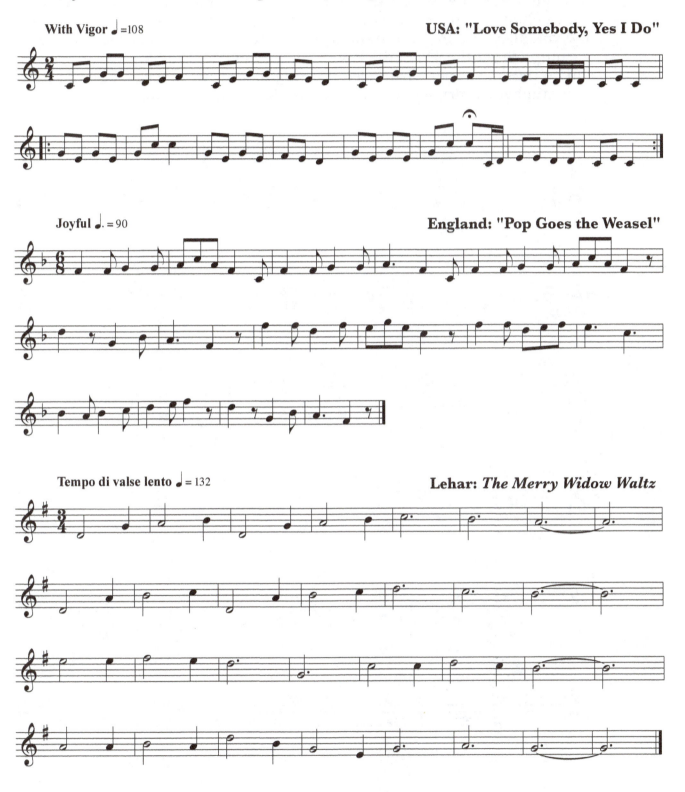

VOCALIZING BEFORE YOU SING

Every musician needs to warm up before they perform. This is true if you are an instrumentalist or a singer. Before you attempt to sing the melodies in this chapter you need to vocalize so your instrument is working for you, and you also need to get into the mode. If the piece is in major sing these warmups to get the feel of the key in which you will be singing. Later you can do these in minor when need be. Sing these with solfeggio or scale step numbers. Start *mezzo piano* and get louder as your voice warms up.

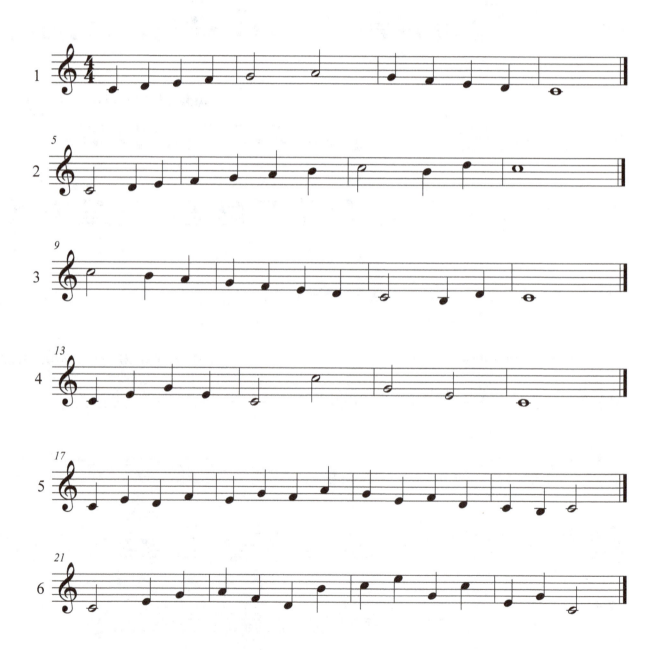

SONG 1

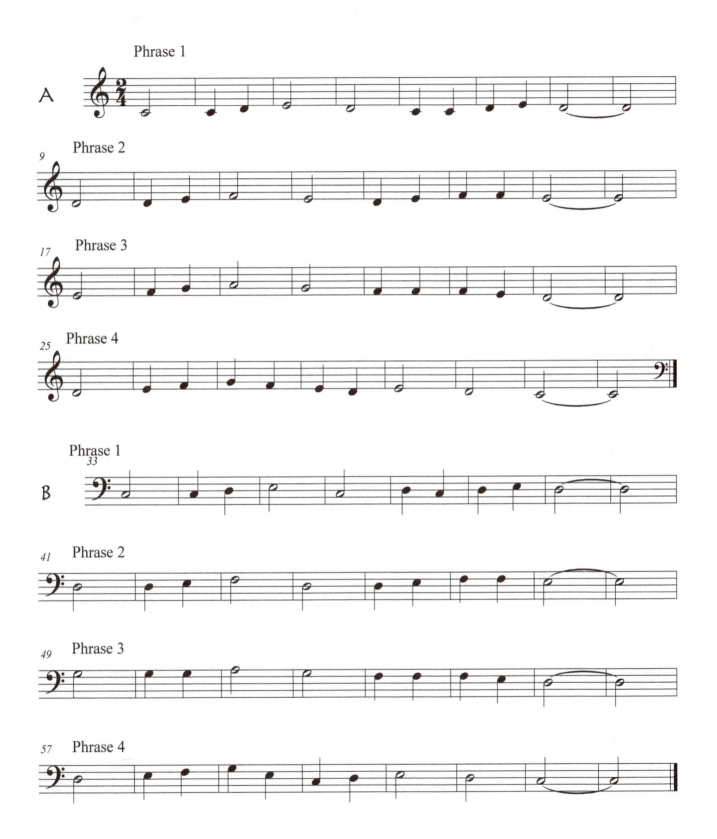

SONG 2

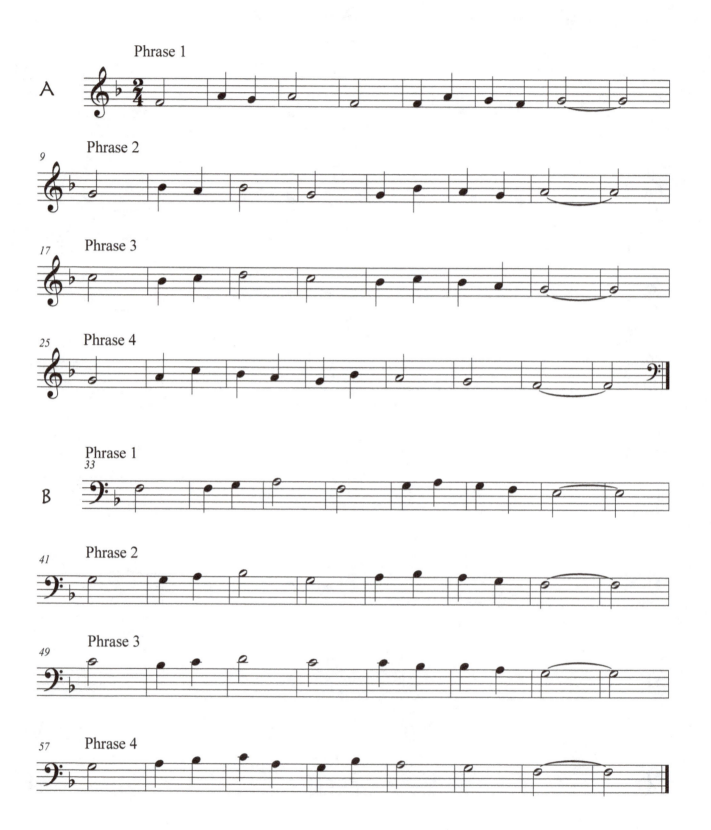

SONG 3

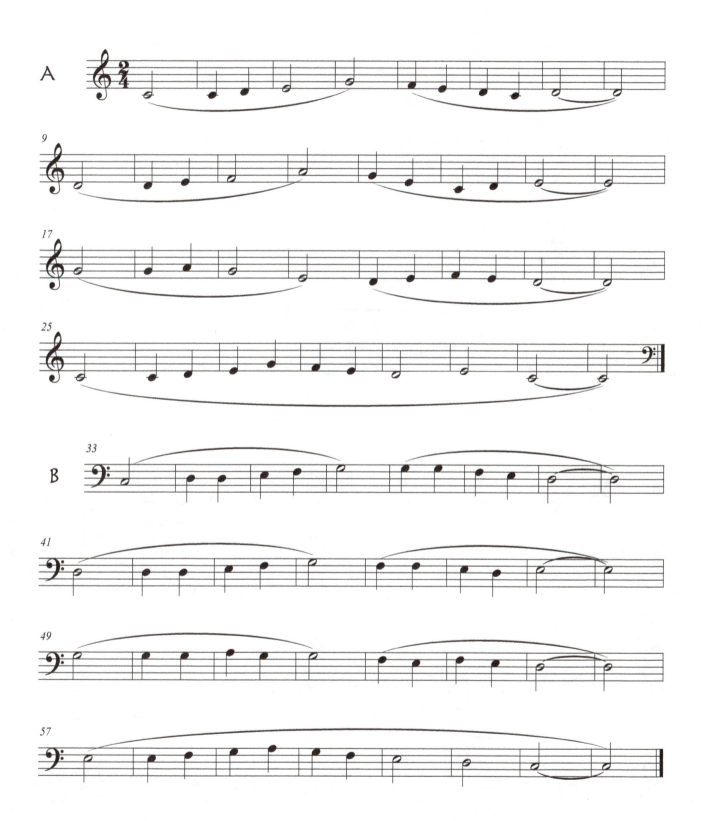

SONG 4

SONG 5

SONG 6

SONG 7

SONG 8

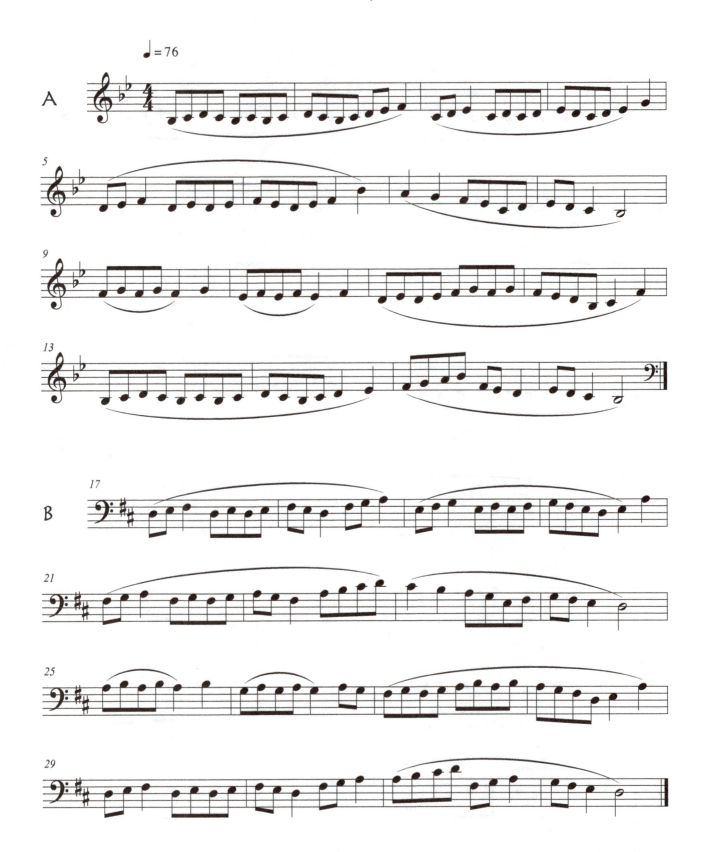

SONG 9

SONG 10

SONG 11

SONG 12

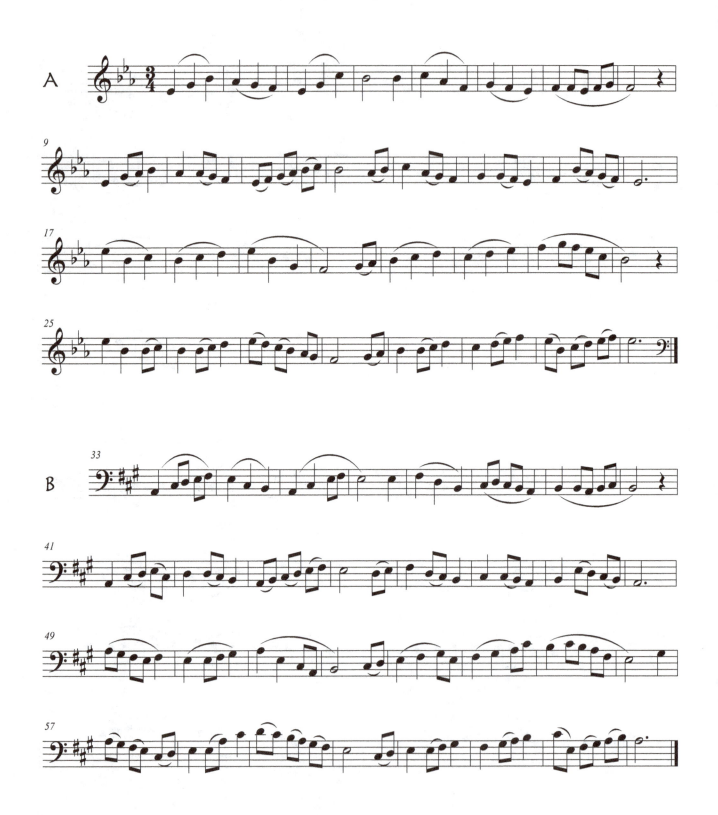

DUET 1

DUET 2

DUET 3

DUET 4

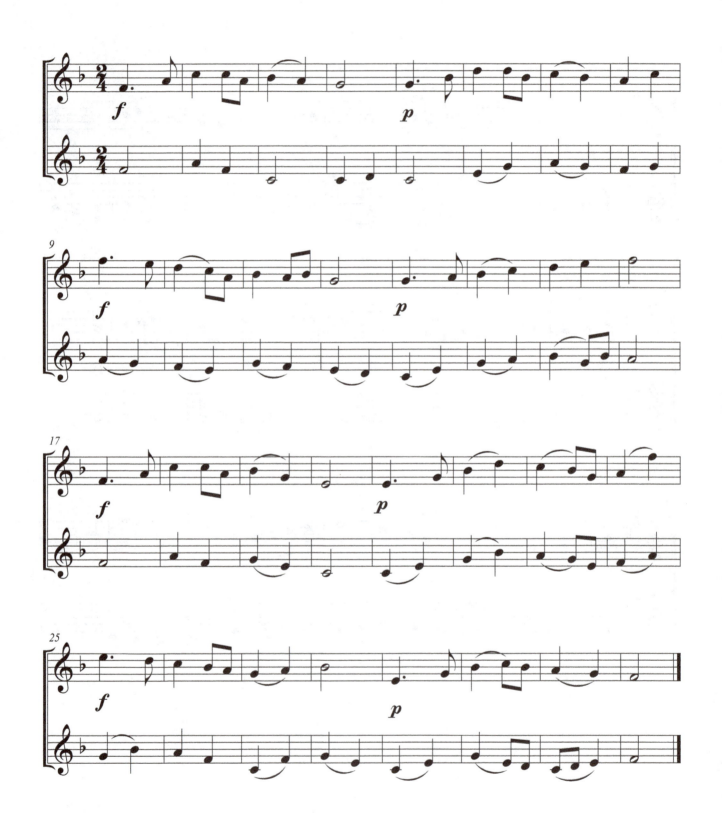

TRIO: HYMN TO FINALS WEEK

Stephen Jablonsky

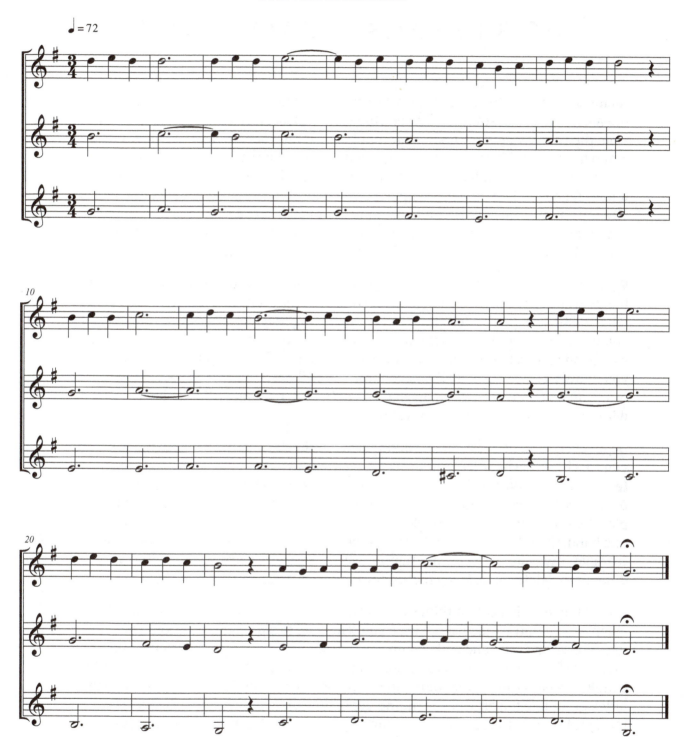

CHAPTER 7
THE KEYBOARD COMPONENT

All musicians need to do two things correctly regardless of whatever else they do in the music business—they need to be able to sing pleasantly so people do not run from the room when they open their mouths, and they need to play the piano. The piano has been with us since the early eighteenth century and it is the instrument we use to realize what harmony is all about. It is on those magic 88 keys that we understand how homophony and polyphony really work. Let's be honest: the world already has enough guitarists and drummers; it needs more piano players, and that is about to be you. When played with control and sensitivity it can be an extra-ordinarily expressive instrument. That's where we're headed.

When a rank beginner first sits at a keyboard the black and white notes seem to blur together into a sea of grey confusion. Fortunately, that condition does not last very long and this chapter is designed to get you playing real pieces as fast as possible. If you were six years old we could take all the time in the world to get you to perform two-hand pieces, but we only have fifteen weeks to make you look and sound like you know your way around the keyboard. You will need to practice seven days a week, no time out, no days off. Even if it is only fifteen minutes, do not let a day go by without tickling the ivories. Life is short.

Begin every practice session by looking over all the data on the printed music before you touch the keyboard. Check the clefs, the time signature, the key signature, the tempo designation, the dynamics, and the articulation. Then look for rhythmic problems, large skips, and accidentals. I recommend singing the piece before you play it so you know what it should sound like. Now you are ready to begin playing one hand, then the other, then both together very slowly. Begin at half speed and work your way up to the proper tempo. It is very easy to learn mistakes, but very difficult to delete them. Many pieces have multiple arrangments. Try them all!

One of the most important things that pianists do is work out their fingerings. That means you identify the places where you will need to shift hand position. You have five fingers on each hand and you need to place them over the next group of notes so that your finger movement is as smooth and easy as possible. The principle is quite simple: we either move the thumb under the index or middle finger, or we take the index or middle finger over the thumb depending on what direction the line is moving. Feel free to use a pencil to mark your score with critical fingerings just like the pros. Some of the tricky spots already have fingerings indicated.

Your ultimate goal is to play beautifully without looking at the keyboard. If you practice slowly and carefully you will develop proper eye-hand coordination so you do not have to keep bobbing your head up and down. Learning your scales and chords will aid in this endeavor so play them every day. Enjoy!

THUMB UNDER, THREE OVER

This compositional masterpiece should get you started thinking about changing hand positions by turning your thumb under the middle finger or bringing the middle finger over the thumb. I have given you the fingerings in the first four measures to get you started. The number 5 is the pinky and 1 is the thumb. Feel free to indicate where the thumb goes under or three goes over in the rest of the piece. Here the two lines move in contrary motion so the hand positions change at the same time. When the lines move in parallel motion they change at different times and things get a little harder but the principle is the same. You will need to be able to shift hand positions by the time you get to Week 5 so start practicing now. When playing certain scales you may need to do thumb under 4 and 4 over thumb. But, above all, never put your thumbs on black keys when playing scales.

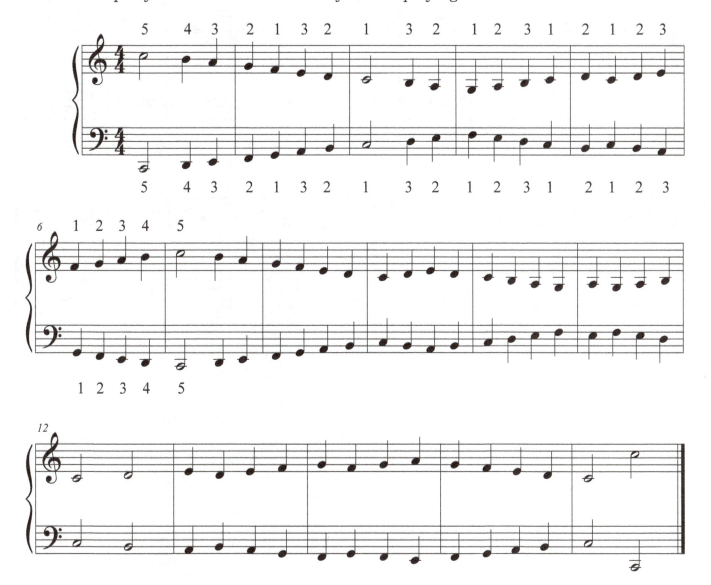

COPY KAT 1

COPY KAT 2

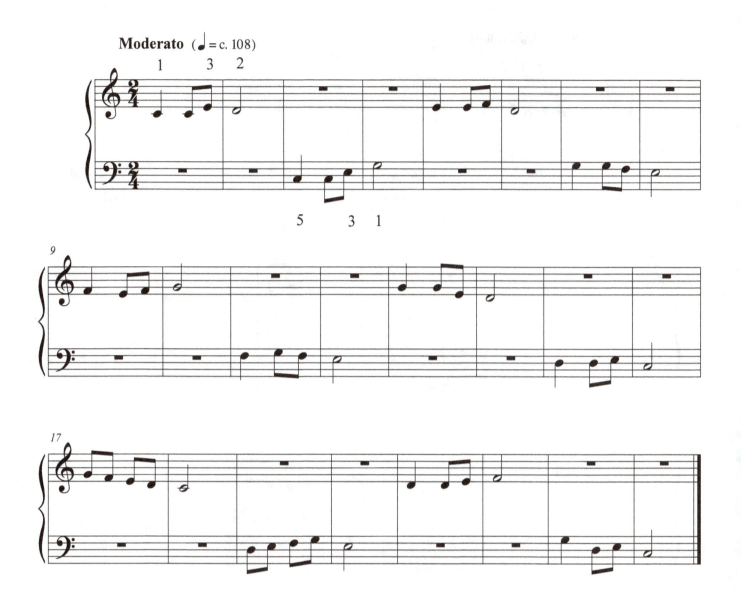

COPY KAT 3

Moderato (♩ = c. 108)

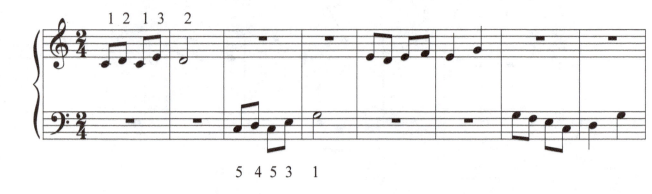

COPY KAT 4

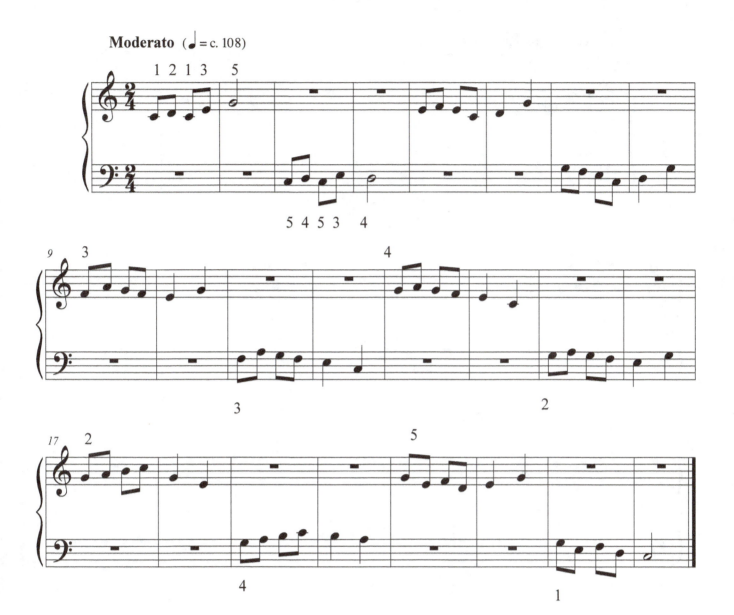

COPY KAT 5*

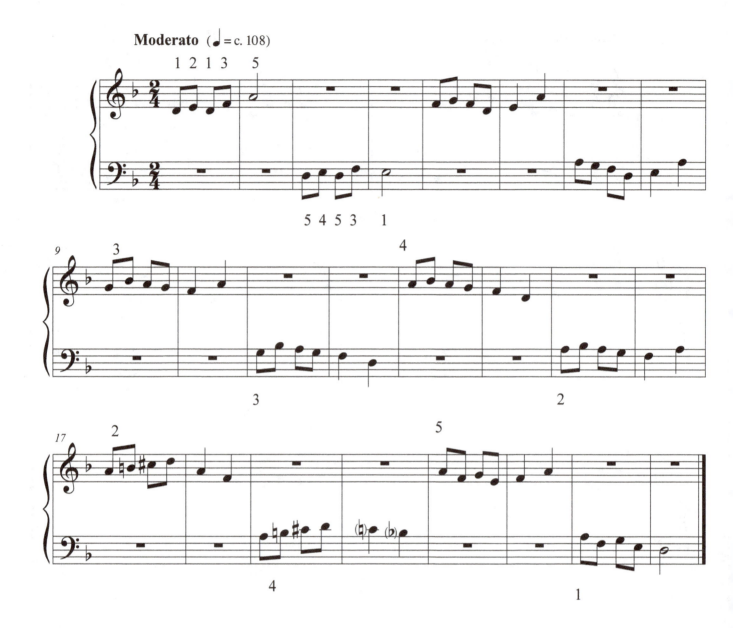

*This is Copy Kat 4 transposed into D minor. It is almost exactly the same piece only the scale that is being used gives the piece an entirely different feeling.

COPY KAT 6*

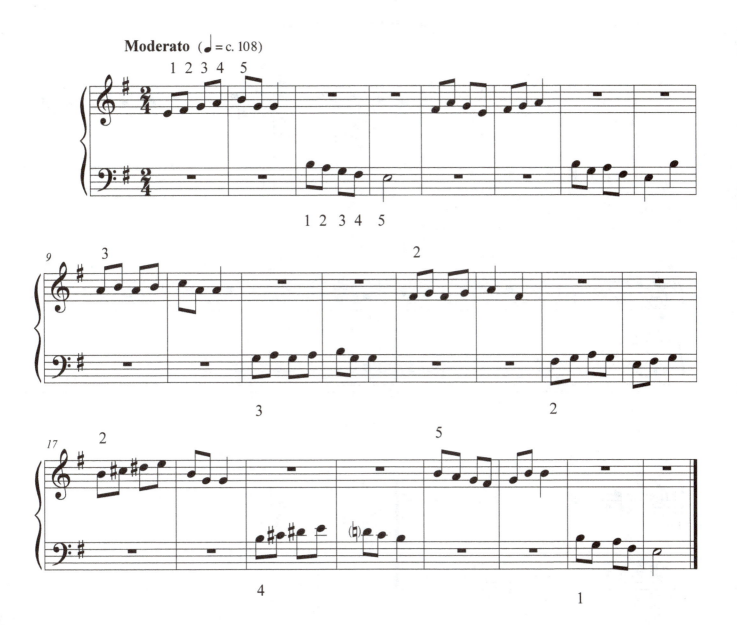

*This is a variation of Copy Kat 5 transposed into E minor.

DOS MANOS 1

STEPHEN JABLONSKY

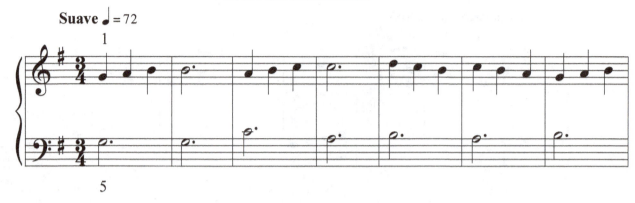

Welcome to the wonderful world of real piano playing. Now you are reading two clefs at the same time and are using both hands together. Begin by playing very slowly. Do not look at the keyboard. If you get into that habit you will always be a keyboard cripple. If your fingers are in the right place, you just have to drop them onto the keys and all will be well. Next stop--Carnegie Hall!

DOS MANOS 2

STEPHEN JABLONSKY

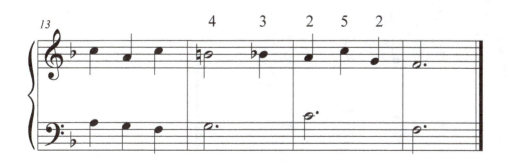

DOS MANOS 3

STEPHEN JABLONSKY

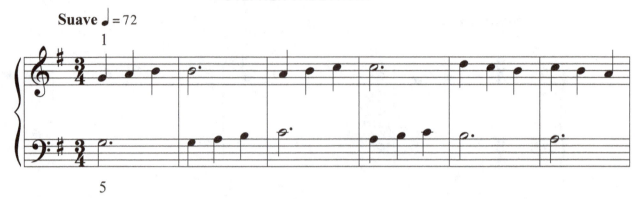

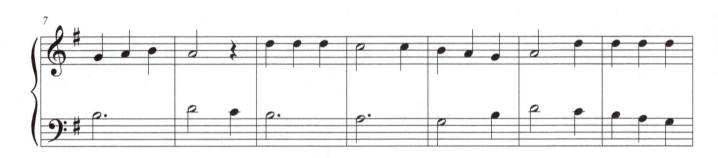

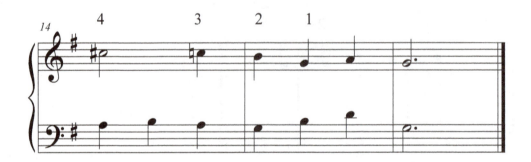

DOS MANOS 4

STEPHEN JABLONSKY

POLLY WOLLY DOODLE 1

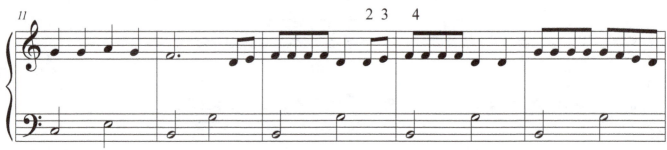

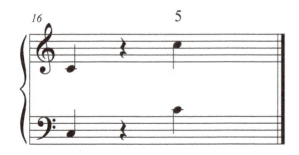

The incomplete pickup measure
at the beginning is balanced by the
incomplete last measure. Together
they form one measure.

POLLY WOLLY DOODLE 2

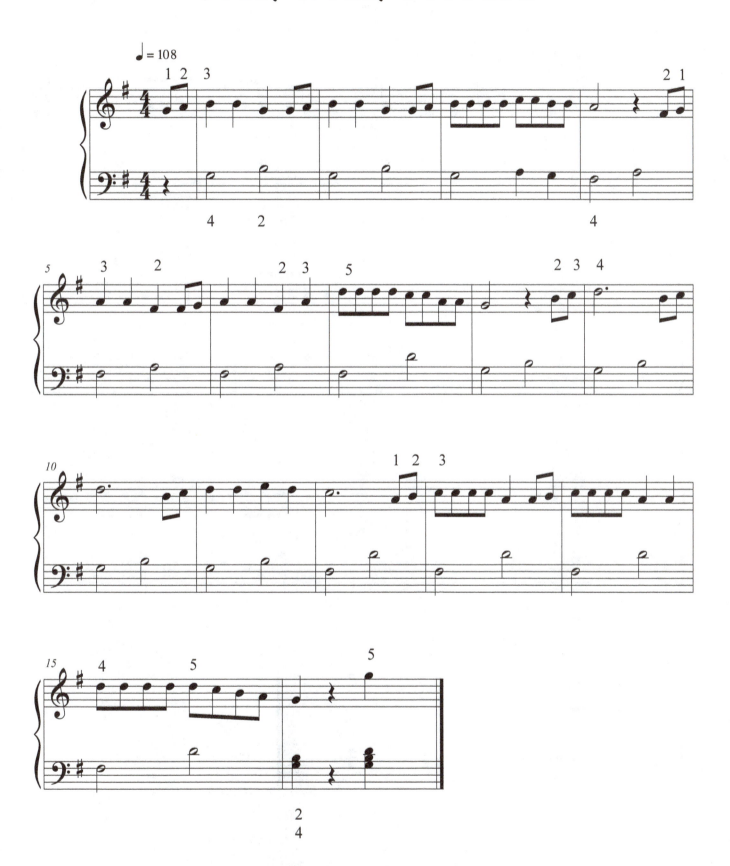

POLLY WOLLY DOODLE 3

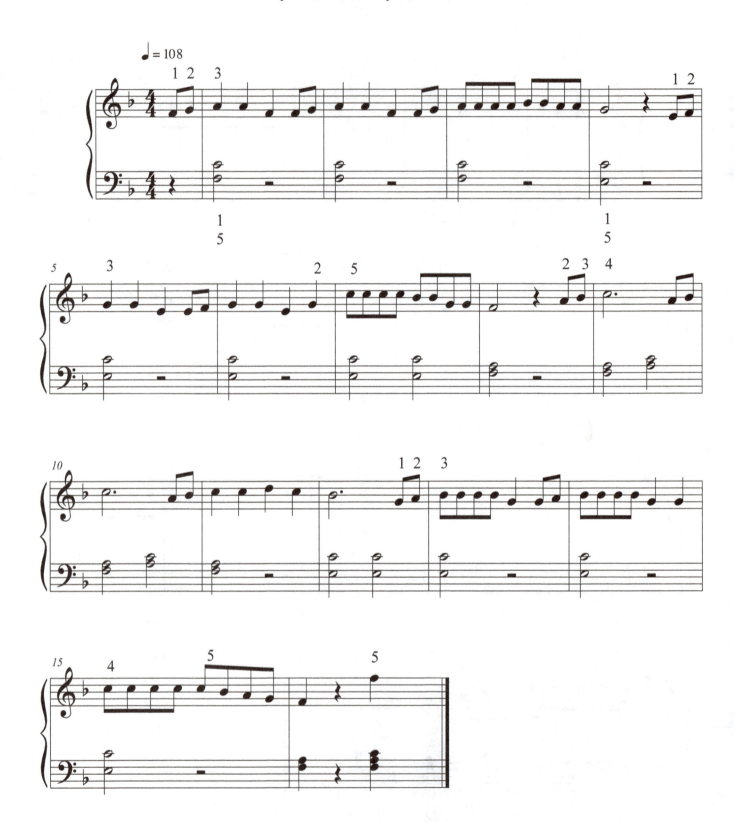

BLOW YE WINDS IN THE MORNING 1

SEA CHANTEY

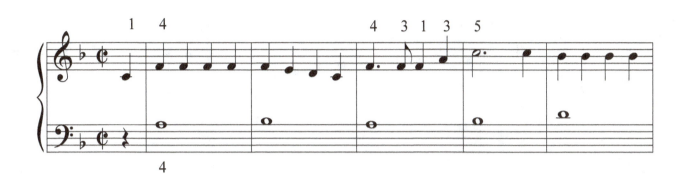

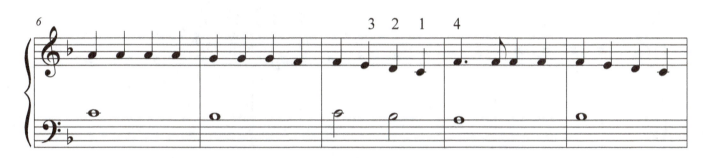

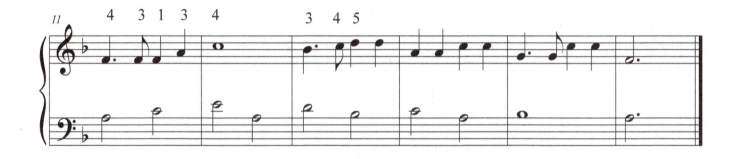

BLOW YE WINDS IN THE MORNING 2

SEA CHANTEY

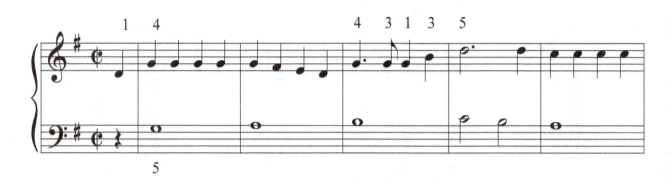

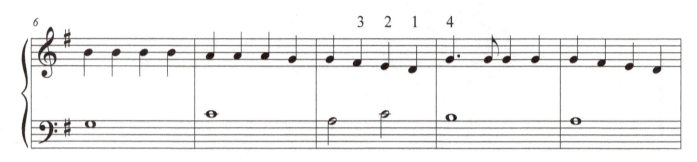

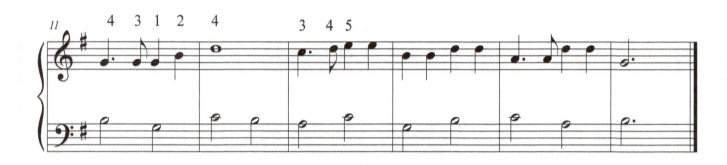

SAKURA 1

CHERRY BLOSSOMS

JAPANESE FOLK SONG

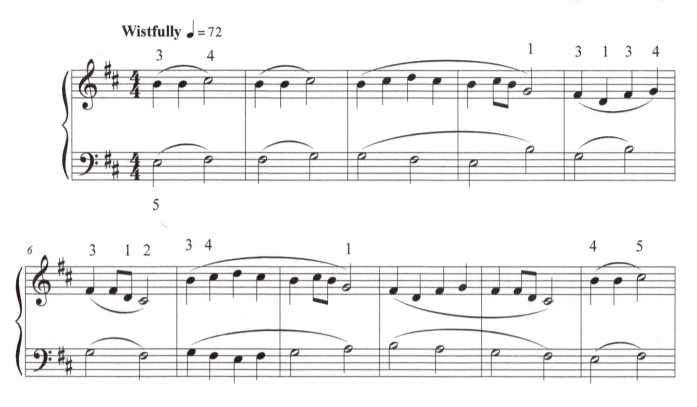

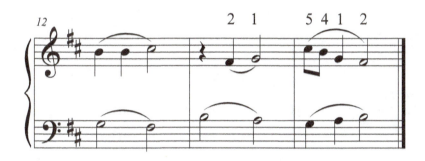

SAKURA 2

CHERRY BLOSSOMS

JAPANESE FOLK SONG

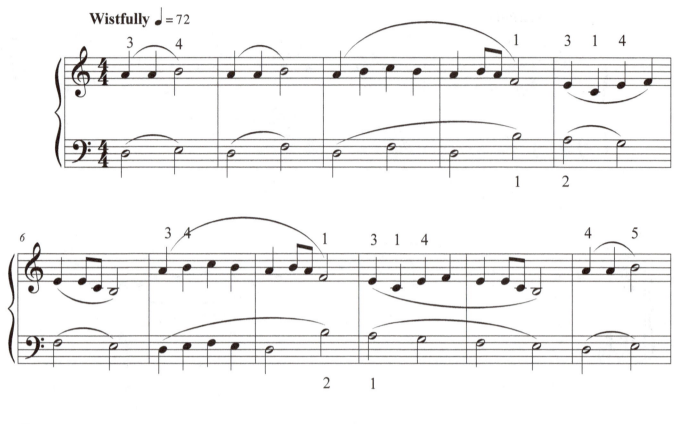

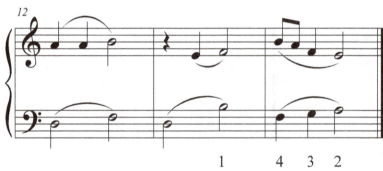

HOME SWEET HOME 1

H. C. Bishop

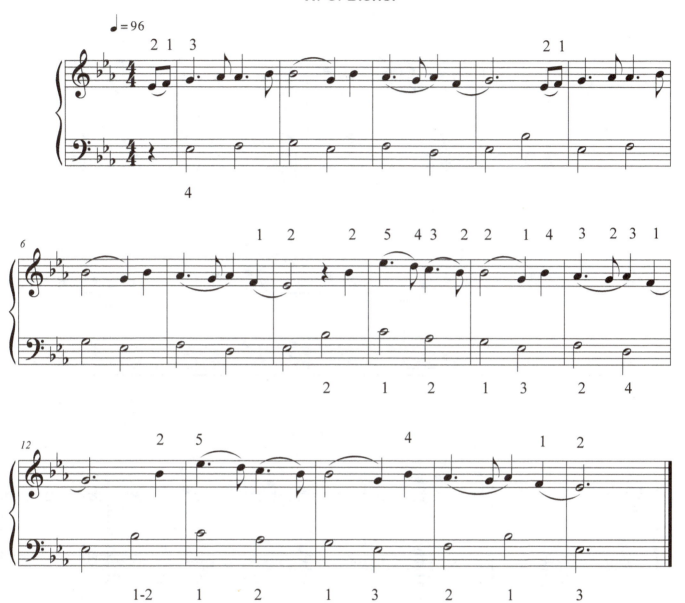

HOME SWEET HOME 2

H. C. Bishop

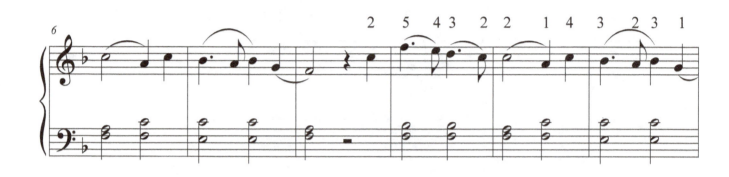

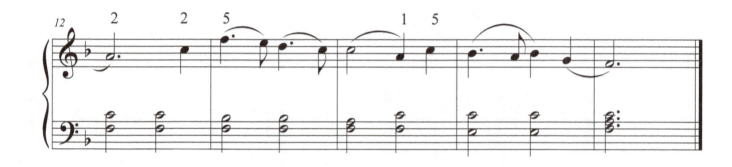

HOME SWEET HOME 3

H. C. Bishop

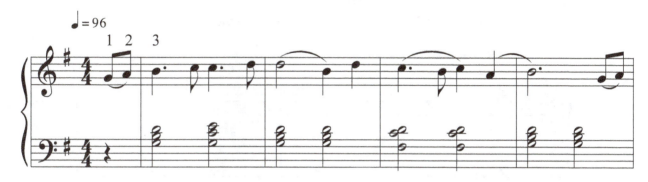

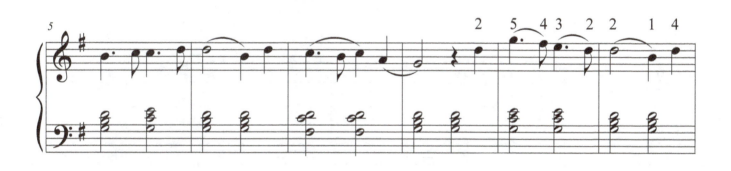

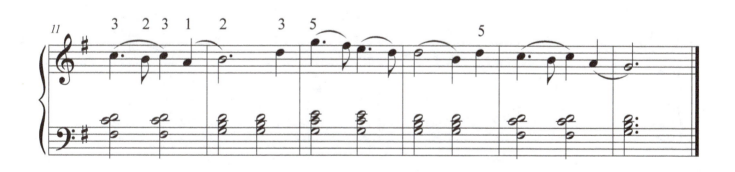

GOOD KING WENCESLAS 1

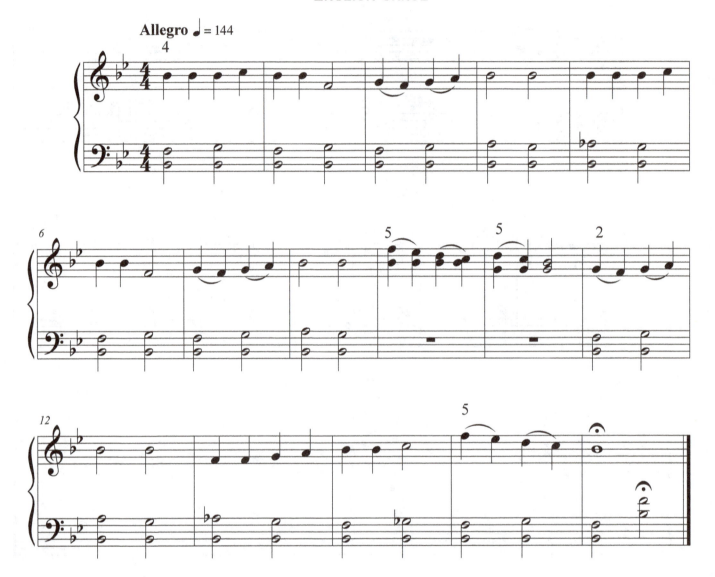

English Carol

GOOD KING WENCESLAS 2

ENGLISH CAROL

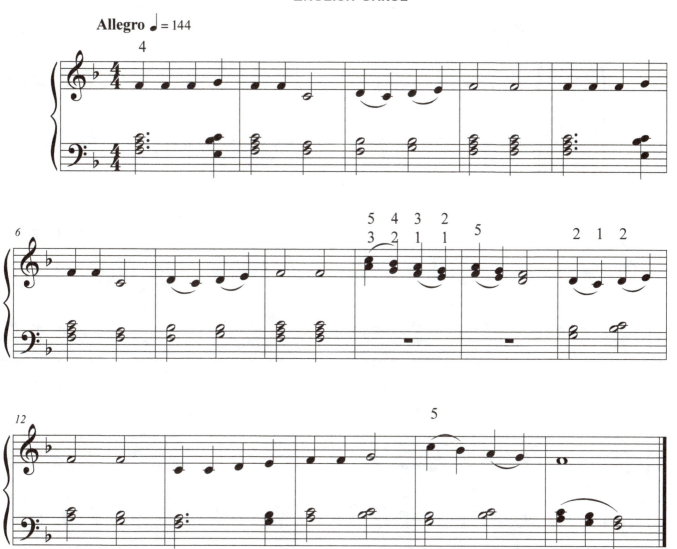

GOOD KING WENCESLAS 3

ENGLISH CAROL

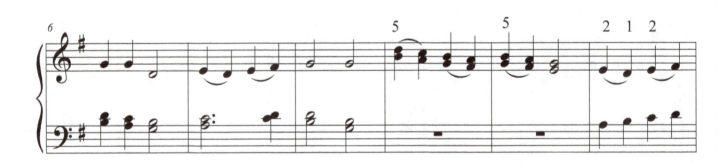

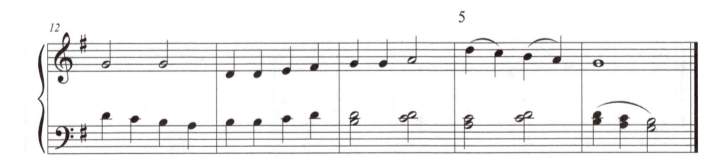

CRADLE SONG 1

Johannes Brahms

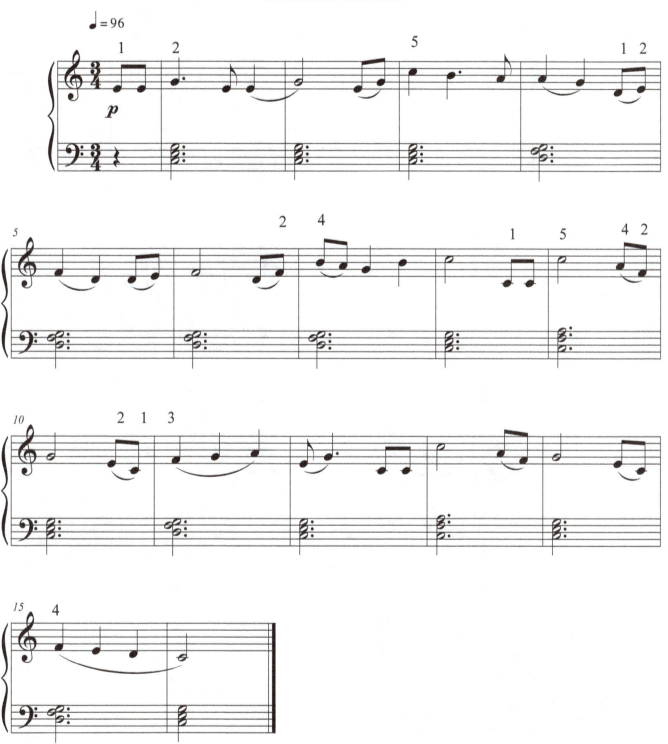

When this piece is well in hand arpeggiate the chords.

CRADLE SONG 2

Johannes Brahms

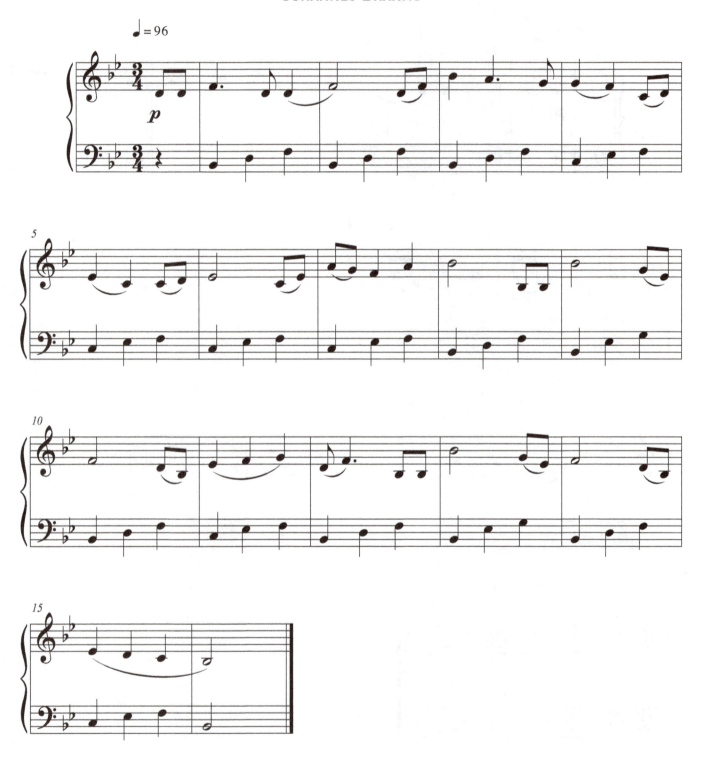

CRADLE SONG 3

JOHANNES BRAHMS

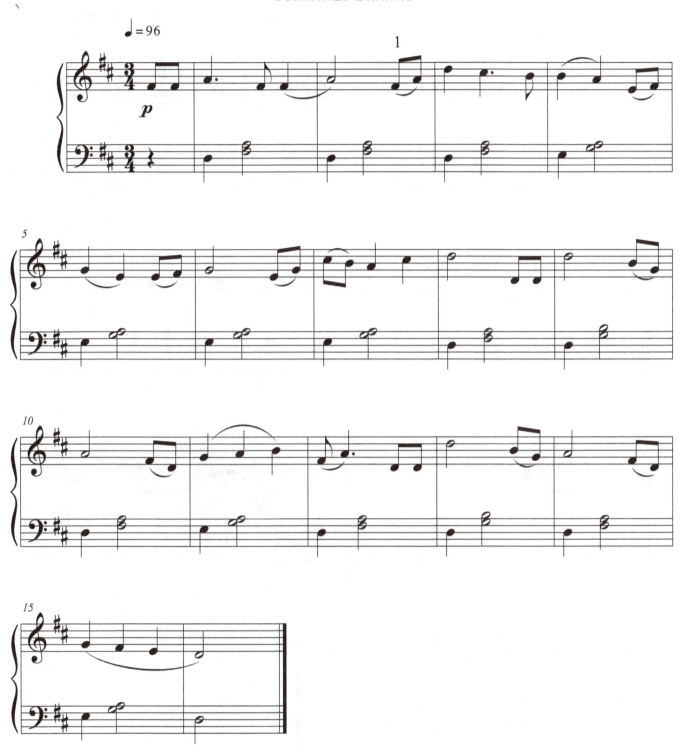

SIMPLE GIFTS 1

AMERICAN SHAKER SONG

JOSEPH BRACKETT

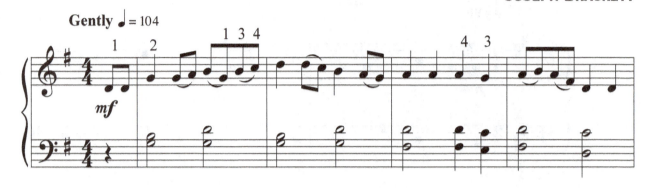

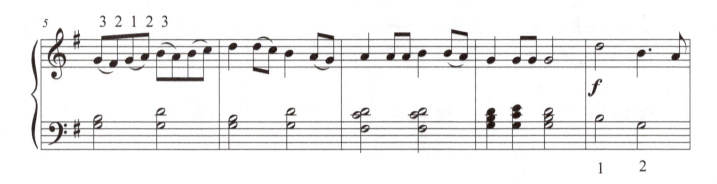

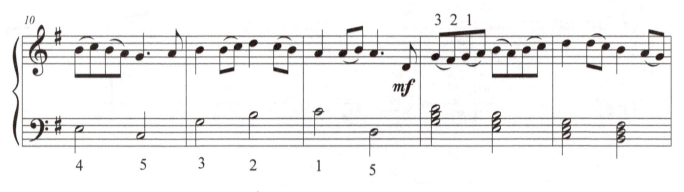

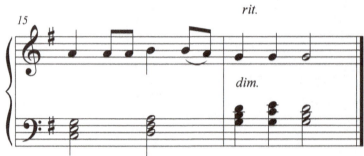

SIMPLE GIFTS 2

AMERICAN SHAKER SONG

JOSEPH BRACKETT

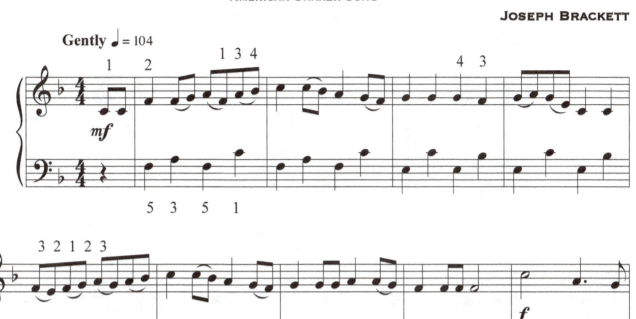

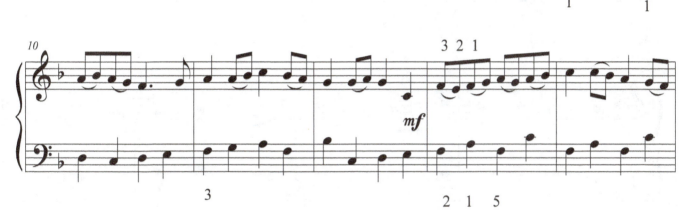

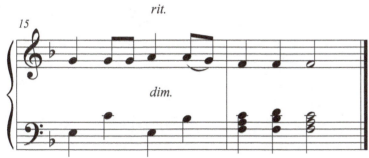

DRINK TO ME ONLY WITH THINE EYES 1

OLD ENGLISH AIR

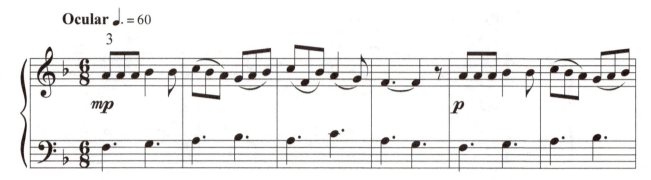

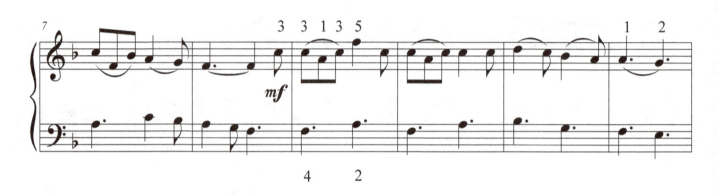

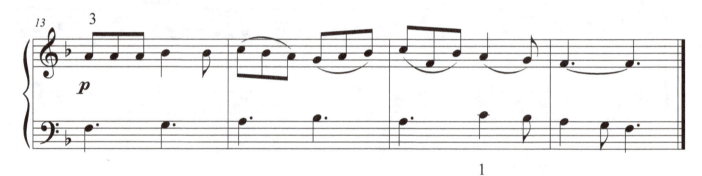

DRINK TO ME ONLY WITH THINE EYES 2

OLD ENGLISH AIR

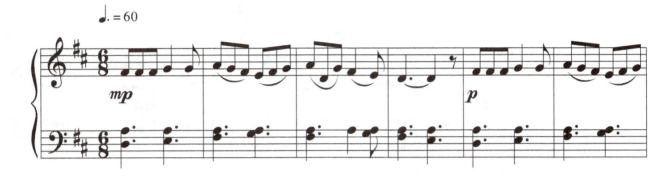

DRINK TO ME ONLY WITH THINE EYES 3

OLD ENGLISH AIR

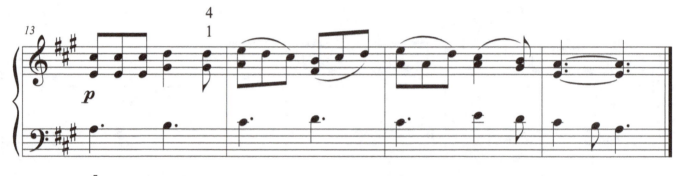

MERRY WIDOW WALTZ 1

Franz Lehar

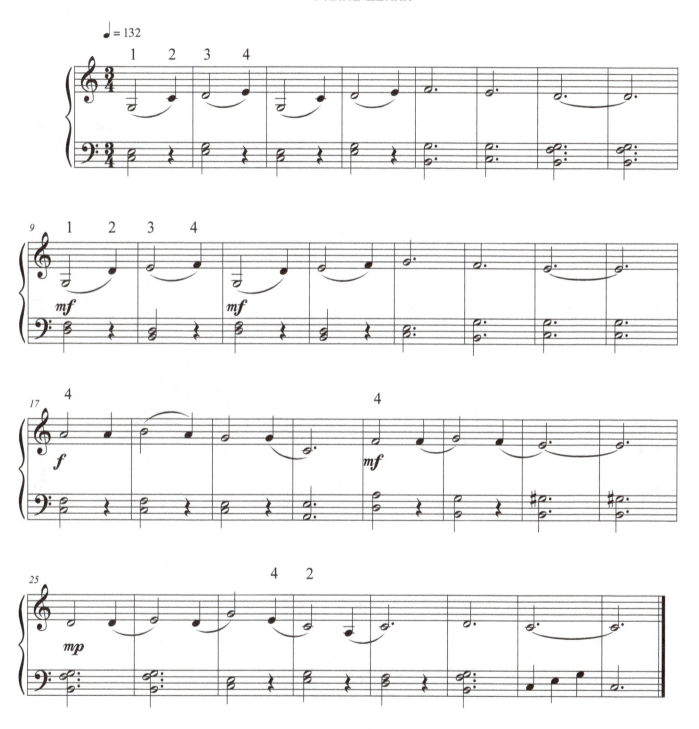

MERRY WIDOW WALTZ 2

Franz Lehar

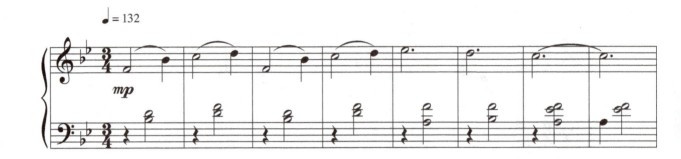

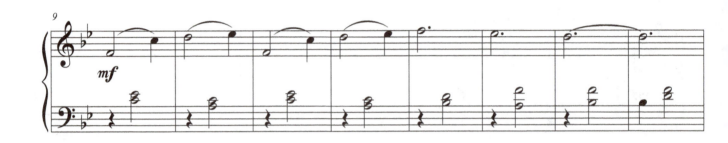

MERRY WIDOW WALTZ 3

FRANZ LEHAR

ADVANCED VERSION

SILENT NIGHT 1

Franz Gruber

When this is well in hand you can arpeggiate the triads in the left hand.
The chord in measure 11 reminds us that life is, indeed, bittersweet.

SILENT NIGHT 2

Franz Gruber

SILENT NIGHT 3

Franz Gruber

MARCHE SLAV

Pyotr Ilyich Tchaikovsky

* You should have worked harder this semester if you really wanted to be a music major.

Glossary of Musical Terms

Accidentals: The flats (♭), sharps (♯), or naturals (♮) used to change pitch.

Alto: The lowest female voice or an instrument that plays in that range; or a type of C clef.

Arpeggio: The notes of a chord played in succession, not simultaneously.

Articulation: The way two consecutive tones are connected (*legato*) or detached (*staccato*).

Bass: The lowest male voice; or the F clef that is used to notate the tones below middle C.

Beat: The regular pulse underlying all metrical music; often confused with rhythm.

Binary: A musical form that is in two parts often separated by a full cadence.

Cadence: The rhythmic, melodic, and/or harmonic way a phrase ends.

Chord: Any three or more notes used as a harmonic unit; may contain 3 to 12 notes.

Chromatic: Music that frequently uses most or all twelve semitones within an octave.

Clef: A sign used to indicate the placement of notes on the staff. The ones in common practice are the G clef (treble), the F clef (bass), and the C clef (alto or tenor).

Composer: An obsessive-compulsive individual who spends much of their life creating music in a desperate attempt to let others know how they feel. They often die young.

Conjunct: Music that moves mainly by step and is usually easier to perform than disjunct music. Conjunct music often feels smooth and controlled.

Consonant: Pleasant sounding harmony; music without tension.

Counterpoint: The art or craft of writing polyphony; or a line that accompanies the melody. It is short for point-counter-point (note against note).

Density: The quantity of different notes or parts played simultaneously. It may range from a solo to an immense orchestra and/or chorus.

Disjunct: Music that moves mainly by skip. The bigger the skips the more difficult it is to perform or to follow as a listener. It may occasionally feel wild and crazy.

Dissonance: Harmonic tension. It is often followed by a resolution to consonance.

Dominant: The fifth note of a major or minor scale, or the chord built on that note.

Duet: Music for two individual performers who are, hopefully, playing in tune with each other.

Duple: Refers to meter that has two beats per measure. Example: 2/4 time.

Duration: The length of a piece of music. It may range from seconds to hours.

Dynamics: The range of loudness as indicated by terms such as *piano* and *forte*.

Ensemble: A group of musicians performing the same piece at the same time.

Folk music: Music performed by ordinary people who are often vary talented but may be musically illiterate or lack conservatory training. In America much of it is played on stringed instruments such as the fiddle, guitar, or banjo by people with bad teeth.

Fool: Someone who struggles to begin learning music past the age of 21.

Harmony: The practice of combining different notes simultaneously; the use of chords.

Heterophonic: a musical texture in which everyone plays the same melody with slight variations or differing embellishments.

Homophonic: Music that has one melody accompanied by chords.

Interval: The distance between two notes as measured in scale steps.

Inverted: A chord in which the root is not the lowest note.

Key signature: The flats or sharps at the beginning of a piece that indicate the key.

Key: Music that employs the notes of a major or minor scale is said to be in a key.

Keyboards: Instruments that have an array of black and white keys such as the piano, organ, harpsichord, or celesta. The piano has 88; usually more than you need.

Major: Scales that use the following sequence of whole and half steps: W W H W W W H. Perceived as happier than minor. Should be practiced every day.

Measure: The distance between the strongest regularly accented beats. In music notation it is separated by two bar-lines.

Medium: The type of instrument or voice that is producing the music, either acoustic or electronic. The medium is often a significant part of the message.

Melody: A succession of tones that seem to have a formal coherence; a tune.

Meter: The grouping of beats into regular patterns of accented and unaccented. It may be duple, triple, compound, or mixed. Clapping the beats helps you find the meter.

Metronome: An instrument used to measure beats per second. Does not do *rubato*!

Minor: Scales that employ a lowered third degree. Perceived as sadder than major.

Monophonic: Music that contains only one line.

Music theory: An attempt to explain why music sounds the way it does. A masterpiece is greater than the sum of the theories that try to explain it.

Natural: A note that is neither flat (♭) nor sharp (♯). Example: E♮

Noise: A sound consisting of numerous random pitches; the opposite of tone.

Opus: Latin for work. A publisher's numbering system. The plural is *opera*.

Pentatonic: A scale having five notes, two less than the seven of major and minor.

Performer: Often a highly skilled musician who thinks they know better than the composer how a particular piece should be played. They are usually overpaid (popular) or underpaid (classical and jazz), and often have egos that outstrip their talent.

Phrase: The musical equivalent of a sentence. It ends with a cadence and a breath.

Pitch: The sound of a note as measured in vibrations per second. A♮ is 440Hz (cps).

Polyphonic: Music that contains two or more lines. It is often hard to write properly.

Popular music: Music designed to reach the widest possible audience. It is often associated with huge sums of money, illicit drugs, and hysterical teenagers.

Range: The distance between the lowest and highest notes that are sung or played.

Register: The range in which a collection of pitches are found. It may be high, middle, or low; also the place where paltry profits are stored in jazz clubs and the like.

Rhythm: The relative duration of notes and the silence between them.

Root: The note on which a chord or triad is built.

Scale: A succession of step-wise tones that span an octave. It often goes up and down.

Semitone: The smallest scalar interval; a half step. Example: C to C♯ or E to E♭.

Soprano: The highest female voice or the uppermost part in a harmony.

Staff or Stave: The five lines that are used in music notation. It contains four spaces.

Subdominant: The fourth step of the major or minor scale, or the chord built on that note.

Tempo: The speed of a piece as indicated by a word (usually Italian) or metronome marking. It usually ranges from *largo* to *presto* with *andante* and *allegro* in between.

Tenor: The highest male voice, or a type of C clef. In opera he is usually the hero.

Ternary: A musical form that is in three distinct parts. It is often A-B-A.

Texture: The fabric of the music; the relationship of the parts. The way musical lines are woven together. It may be monophonic, homophonic, polyphonic, or heterophonic.

Tonal: Music that uses the scales or harmonies of major or minor.

Tone: A sound of measurable pitch as opposed to a noise; or the quality of the sound.

Tonic: The first step of a scale; also a refreshing drink or hair product.

Treble: The G clef that is used to notate the tones above middle C.

Triad: A chord consisting of three notes built in thirds. Example: C – E – G.

Trio: Music that contains three individual parts, or three people who perform together.

Triple: Music that has three beats per measure. Example: ¾ time.

Unpopular music: Music designed for a small discriminating audience. This includes most classical music and contemporary jazz. Tickets are either free or very expensive.

Volume: The loudness of the music as measured in decibels. 125dB really hurts!

Whole step: An interval that contains two semitones. Example: A – B (bypasses B♭).

ABOUT THE AUTHOR

Professor Jablonsky began his musical life as a trumpet student of Edward Treutel, Wes Lindskoog, Robert Nagel, and Charlie Colin. For the past half century he has been on the music theory and composition faculty of The City College of New York. His compositional studies began with Morris "Mark" Lawner at the High School of Music & Art and continued at CCNY with Mark Brunswick, William Dabney Gettel, and Paul Turok. He pursued graduate studies with Pierre Boulez and Leon Kirchner at Harvard University and received his Ph. D. degree from New York University in 1973. His doctoral thesis, *The Development of Tonal Coherence as Evidenced in the Revised Operas of Giuseppe Verdi*, was supervised by Martin Chusid.

In 1976, while he was also a senior conducting fellow at the National Orchestral Association studying with Leon Barzin, he received a National Endowment for the Arts grant to complete a major multi-media work entitled *Wisconsin Death Trip* that was performed by both the New York Philharmonic and the Milwaukee Symphony Orchestra and was received with much acclaim. Over the last four decades more than three dozen of his music compositions have been performed around the world. With the introduction of personal computers he turned his attentions to the world of MIDI composition and since 1991 has produced more than thirty pieces in that medium. He is also the author of a slew of theory and musicianship textbooks that students seem to enjoy using despite the daunting nature of the subject matter.

Interestingly, his greatest fame comes from his artistic endeavors. Currently, more than 200 of his paintings adorn the walls of five buildings on the City College campus. During the 1970s and 1980s his *Musigraphics* were collected by music lovers around the globe.

DEDICATION

This book is dedicated to my father, Ben Jablonsky, who was my first music teacher and always encouraged me to play the right notes on the right beats with musical sensitivity and attention to nuance.

Stephen Jablonsky
Stamford CT
December 5, 2013